SPRATLING SILVER

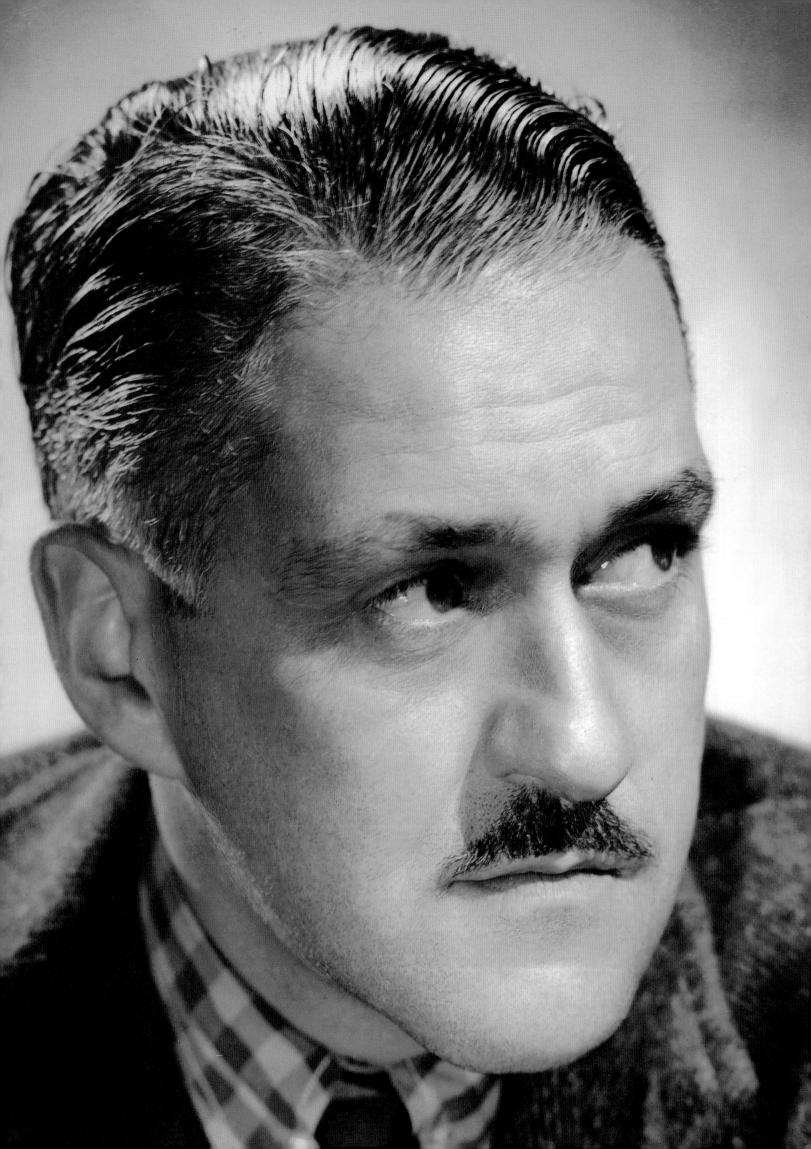

SPRATLING SILVER

Centennial Edition

SANDRALINE CEDERWALL
AND
HAL RINEY

Essay by Barnaby Conrad

CHRONICLE BOOKS

SAN FRANCISCO

Library of Congress Cataloging-in-Publication Data available.

Printed in Hong Kong

ISBN: 0-8118-2954-5

Book Design: Woody Lowe
Photography: Avis Mandel and Alan Ross

Distributed in Canada by Raincoast Books
9050 Shaughnessy Street
Vancouver, BC V6P 6E5

10 9 8 7 6 5 4 3 2 1

Published by Chronicle Books LLC
85 Second Street
San Francisco, CA 94105

www.chroniclebooks.com

His objects evoke a sense of feeling, respect, and pleasure.

The details of his designs honor ancient Mesoamerican sculpture, remind of things in nature,

hint at important events, or suggest the individuals that influenced him.

His vision provides inspiration. He had integrity and was in touch with his heart and soul.

He believed in humanity and in humankind's imagination and our ability to create with our hands.

During his sixty-seven years he sifted through everything

and then with his intimate silver designs presented us with the essence of life.

It is with great respect that I dedicate this volume to the genius William Spratling

and commemorate the hundredth anniversary of his birth

in this millennium year of 2000.

— Sandraline Cederwall

Contents

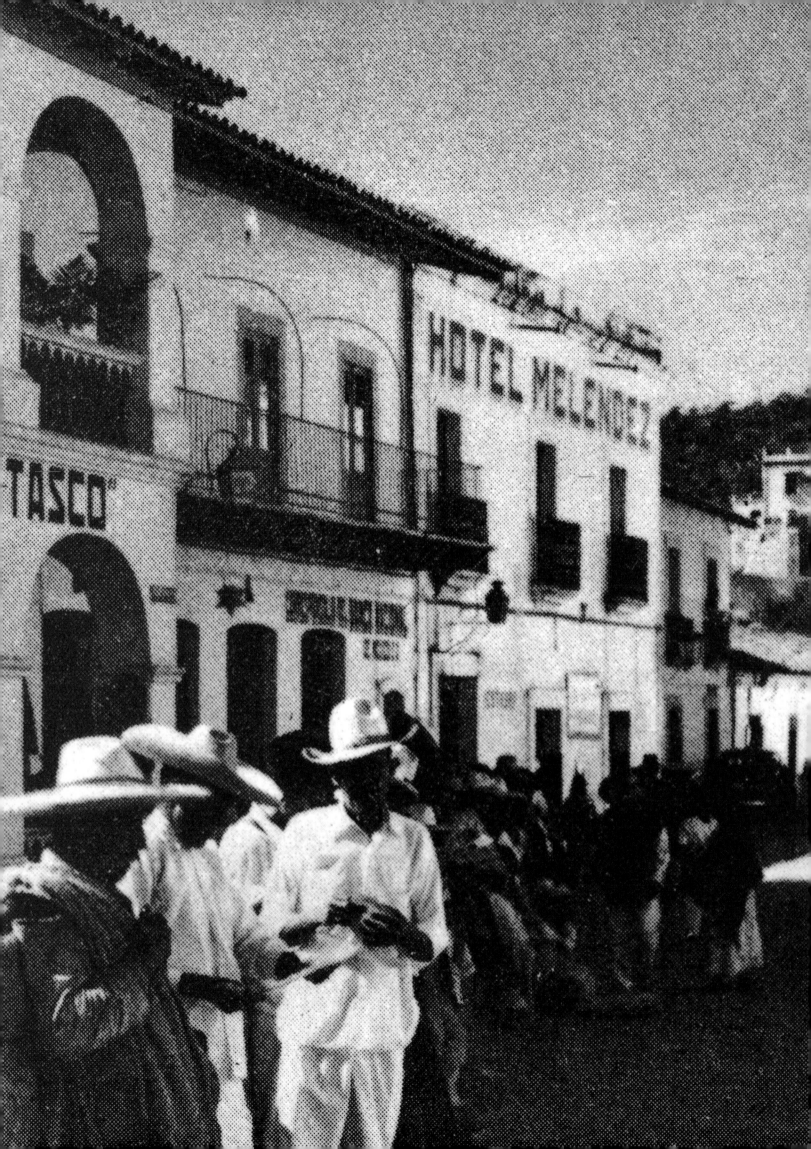

P r e f a c e

My admiration for the work of William Spratling was born years ago. While looking through a collection of otherwise ordinary silver objects, I came across a tiny box (page 73) bearing the hallmark of Spratling's Taxco studio. That small discovery began a lifelong interest in this extraordinary artist and designer, eventually leading me to Taxco, where I encountered firsthand his remarkable contribution to Mexico's silver industry. The original 1990 edition of *Spratling Silver* was conceived as a catalog to accompany a display of Spratling's work installed in a store Hal Riney and I owned in San Francisco. The expatriate American's unusual silver designs captured my attention and the display grew into an exhibit of nearly three hundred pieces. The longer I worked on the exhibition, the more I wanted to tell Spratling's remarkable story, a story virtually forgotten since his tragic death in 1967. The simple catalog evolved into a beautiful book. Over the past ten years that publication has played a major role in once again affording William Spratling the recognition he and his silver designs deserve. It has also helped to repopularize the entire Mexican silver industry. This book is a much requested expansion of the 1990 edition.

— *Sandraline Cederwall*

Spratling Designs

Willam Spratling produced memorable silver jewelry and hollowware for forty years. The fine quality of his silver work was consistent; each decade brought different interpretations inspired by his interest in history, culture, nature, and politics. Through photographs, this book presents rare, classic, and common examples of his work. Though merely a sampling of Spratling's prolific career, this selection of his silver creations reflects the strength and vigor of the unending variety of design ideas that flowed from his senses and his soul. 🐟 Spratling mastered the art of silver design, incorporating powerful indigenous, pre-Columbian motifs; centuries of Spanish influence on Mexican culture; the Mexican love of birds, animals, flora, and all things human; as well as ideas inspired by his work with Inuit artists in the Arctic. With an eye for detail enhanced by architectural training, he tempered it all with his own intelligent, simple, restrained style. 🐟 Many of William Spratling's first strong and appealing creations were his interpretations in silver of pre-Hispanic clay seals. He drew inspiration from Mexican *charro* and *ranchero* motifs. Ultimately he was influenced by everything he came in contact with. His work was modern and universal, representational or abstract. It was always practical. The common denominator that runs throughout all of his pieces is his integrity – his commitment to fulfill his convictions and to fulfill the potential of silver. 🐟 The necklace on page 59 was inspired by Zapotec art and artifacts. The "smiling god" brooch, page 79, with its three little cascabelles, reflects the

Remojadas art (200 B.C. to A.D. 600) that was rediscovered in 1952. The Remojadas people, though little known, are considered to be descendants of the great artisan civilization of the Olmecs. When my friend Mary Anita Loos gave me an obsidian butterfly (page 77) a few years ago, she said Spratling himself had given her that little treasure. He told her it had taken his worker over a month to carve it. We can find this Aztec-Olmec element incorporated into the detail on the bell on page 107. If Spratling was pleased with a shape, he would use it in many variations. ✦ The jaguar, in its various personalities and moods, appears frequently in jewelry. Sometimes the silver mammal was combined with amethyst cabochons (page 83) or tortoiseshell. Its full body is cast on the tops of a tea set (page 69). The eagle's profile, a silhouette carved as the rosewood handle of the 1930s pitcher on page 123, appears again smaller and more abstract on the handles of the art deco set on page 57. The serpent, important to ancient cultures, is incorporated on boxes (pages 147 and 125), as handles (page 69), as a pendant (page 49), as brooches, and more. ✦ Spratling was also alert to creatures of the sea. The three feet on the bowl (page 85) are his translation of snail shells. The volute shell shape is used again as the connection between the handle and the body of the prototype teapot on page 47. Later pieces of this *ovalado* design evolved with ebony handles (a practical matter since the original silver handle would conduct heat and burn the user). The classic brooch on page 39 is the essence of a sea animal. The very private artist Georgia O'Keeffe, a woman known to have little need for jewelry but always for drama, was photographed wearing this pin on her austere black dress. The little pitcher (page 61) is amusing. The snail shell shape fits snugly into one's grasp, leaving no need for a handle. ✦ By the 1920s and 1930s William Spratling felt that in the

United States, the country of cities and mass production, the American people no longer respected those who worked with their hands. He recognized that neighboring Mexico was in a unique position because the people still worked with their hands to make a living. The importance Spratling gave to this view is reflected by the motif of hands appearing in his designs throughout his career. One of his early silver creations focusing on hands was a pair of bookends (page 55). These objects are a stunning sculptural masterpiece. Well-known later designs for earrings, necklaces, cufflinks, brooches, and even pen holders were created with the motif of the hand. Sometimes the palm is wide open with fingers spread. Other times there is a fist. A mixed-metal brooch displays hands clasped across a map of the Americas. The hand theme was a constant powerful reminder of Spratling's respect for the individual and the ability of the person to use his or her imagination to see and to create. William Spratling spent most of his adult life designing silver. The details of his designs are essential elements that he molded to invite contemplation. While enjoying his silver jewelry, hollowware, and other objects, generations to come will be reminded of important cultures and the relationship of humanity to all things in nature. It is my pleasure to have this book published as a tribute to the great artist and designer, William Spratling.

Sandraline Cederwall
San Francisco, California
August 2000

William Spratling

Spratling was already a household word and a generic term among American residents and tourists in Mexico in 1940, when I went there to study art at the University of Mexico. William Spratling first came to Mexico in 1926, at the age of twenty-six. He died there in 1967. In the interim he changed the silver industry of the country forever, both economically and artistically. First, he taught the people of Taxco to respect and replicate the art of their forefathers; then he showed the stunning results to Mexico and the world. Perhaps no other artisan in history had more influence and impact on the art of an adopted country than William Spratling had on Mexico's silver industry. Today, Spratling's reverent interpretations of Aztec and classical designs and his concepts of how silver should be worked are appreciated more than ever by connoisseurs, museums, and collectors the world over. This is not to suggest that he was unappreciated in his lifetime: At one point he employed some four hundred craftsmen to execute his designs; he was represented in many museums; and people such as Emperor Haile Selassie, Lyndon Johnson, and Orson Welles were collectors of his work. Novelist Budd Schulberg has written: "Author,

Architect, Cartoonist, Silversmith, Merchant, Pioneer, Sailor, Aviator, Tropical Horticulturist, Expert on Medicinal Plants, Pre-Columbian Authority, and one of Central America's most distinguished collectors and Mexicologists, to name only a few. . . . He is the only true Renaissance man I know." I met the legend himself in 1940 at Paco's famous bar in Taxco, the delightful little mountain town that "Guillermo" Spratling had made his own. Tall, lanky, and bespectacled, he was effortlessly charming, I remember, though at that age I was not aware of his importance in the art world. No one could be unaware of his importance in Taxco, however–everywhere he went on the cobbled streets it was "Sí, Don Guillermo," "Cómo no, Don Guillermo," with an obvious respect that bordered on the reverential. It was accorded him genuinely; he commanded respect but never demanded it. He was the undisputed lord of the town, and people came from miles around to pay him homage and bask in his gregarious southern presence–people such as Katherine Anne Porter, Hart Crane, Sherwood Anderson, and Bette Davis. But mostly people came to buy Spratling's unique creations of silver combined with ebony, rosewood, amethyst, black onyx, green onyx, jade, pearls, mother of pearl, topaz,

opals, turquoise, tortoiseshell, copper, obsidian, or gold. His designs, often based on Aztec and Olmec motifs and nearly always having an Indian quality to them, remained unique for only a short time, for his creations were shamelessly copied by lesser jewelry makers in and out of Mexico. But no matter–Spratling's imagination was limitless, and, as fast as his styles were copied, his fertile and talented brain came up with new ones. The Spratling saga began on September 22, 1900, when he was born in Sonyea, New York. His father was from Alabama, a friend of Theodore Roosevelt and the founder of the Craig Colony for Epilepsy. His mother was Anna Gorton, a descendant of the man who founded Rhode Island with Roger Williams. When Spratling was ten, at school in Baltimore, he won a drawing prize, his first artistic recognition. When he was twelve his mother died; his father died two years later. He moved to Atlanta with an uncle, and when he was fifteen he attended the famed Art Students League in New York. He went to Auburn University in Alabama, then taught architecture at both Auburn and Tulane. Almost as talented a writer as he was an artist, he wrote a book, *Sherwood Anderson and Other Famous Creoles,* with his friend and roommate, William Faulkner. Both Faulkner

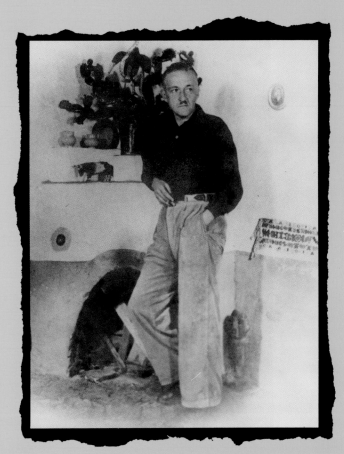

William Spratling at his ranch in Taxco Viejo, Mexico.

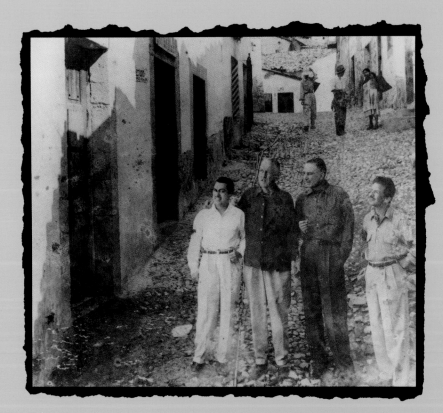

Antonio Castillo, William Spratling, Hector Aguilar, and Antonio Pineda
on Calle de Guillermo Spratling in Taxco. Castillo, Aguilar, and Pineda, one-time Spratling apprentices,
went on to become well-known silversmiths in their own right.

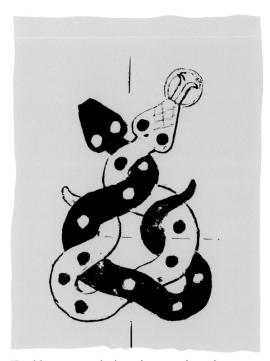

and Spratling drank a lot of Pernod with John Dos Passos in the jazz dives of New Orleans. "Faulkner, of course, drank constantly," Spratling wrote in his 1967 autobiography, *File on Spratling*, "though I must add that I don't think I ever saw him really drunk—perhaps a little vague, but never sloppy. In the morning, once I was out of bed, Bill would already be out on the balcony with a drink, usually alcohol and water, banging away at his typewriter; this was every morning. I think what dominated him was the ideas in his head and not the alcohol. Later he drank as a sort of curtain between him and people who bored him."

In 1926 Faulkner and Spratling went to Europe on a freighter, Faulkner to have fun, Spratling to write and illustrate an article for *Architectural Forum*. Later that year Spratling went to Mexico to lecture on colonial architecture at the National University of Mexico Summer School. He returned there for two more summer sessions. Mexico—its history, its art, its people—became an obsession. He decided he wanted to quit teaching at Tulane, move to Mexico, and write a book called *Little Mexico*, which publisher Harrison Smith had agreed to take on. It took him 3$^{1}/_{2}$ years to write the book, living with people all over Mexico, even risking his life in the forests surrounding the Rio Balsas in the dangerous "Hot

Land." During his wanderings he came across the little village of Taxco and lived there modestly in the Villa Rosada while he finished the book. 🐟 The work was published to excellent reviews, but sales were limited. He had no money or income except what he made by painting an occasional portrait or by writing articles and book reviews for the *New York Times* and *Herald Tribune*. 🐟 A timely windfall solved his problem. Dwight Morrow, the American ambassador to Mexico, wanted to present a fine, lasting gift to his favorite city, Cuernavaca. Spratling convinced him to hire his friend, the artist Diego Rivera, to execute frescoes in Cortés Palace. Spratling set the price at the unheard-of sum of twelve thousand dollars. Morrow agreed, and Spratling accepted a two-thousand-dollar agenting fee from a grateful Rivera. 🐟 With this money, Spratling bought a little house in Taxco on Las Delicias Street and moved in in January 1929. He would stay and work in that house for sixteen years, and Taxco would never be the same. Nor would Spratling: He had fallen in love with Taxco. More important, he had fallen in love with silver. 🐟 "The true color of silver is white," he wrote, "the same color as extreme heat and extreme cold. It is also the same color as the first food received by an infant, and it is the color of light. Its very malleability is an invitation to work it. It lends itself to the forming of objects in planes and in three dimensions of

great desirability, objects to be done by hand in precious metal." Mountainous Taxco was a small, very sleepy town in those days, known primarily as a stop on the road from Mexico City to Acapulco. "The abruptness of the terrain in Taxco," Spratling wrote, "is probably what is mainly responsible for its charm. It is practically a vertical site—the variety of combination, as rooms are adjusted to the separate levels, plus the fact that most of the domestic architecture is humble and on a small scale, with red tile roofs, distinguishes the village from the more palatial architecture of San Miguel de Allende or of Guanajuato. Its very poverty has thus contributed to its character." At one time Taxco had been a bustling mining town, Spain's primary source in the New World for precious metals. Mining gradually decreased in Taxco as richer and more accessible deposits were found elsewhere and the Spanish settlers turned to farming. The silver of Taxco was forgotten for almost two hundred years. Then one day in 1716, Jose de la Borda, a Spanish colonial of French extraction, was riding in the hills of Taxco when his horse's hoof dislodged a stone (as the story goes) that revealed a rich vein of silver. It made Borda fabulously rich, and he became Taxco's patron saint, investing much of his money in the town, building roads, houses, and the magnificent cathedral Santa Prisca, which is still Taxco's focal point. Borda eventually squandered his fortune and

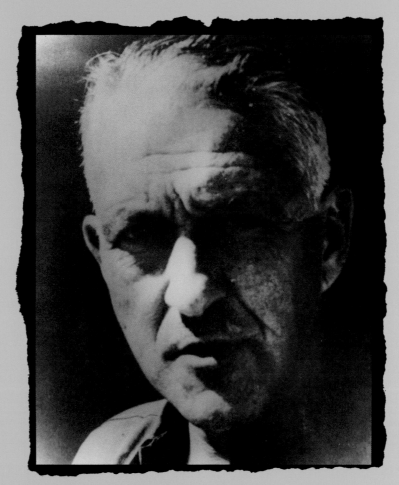

Spratling.

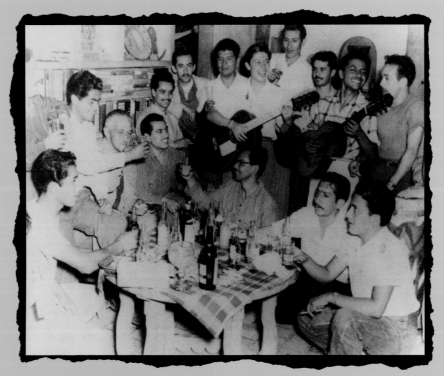

Spratling relaxes with workers and silversmiths at Taller Spratling.

sold his mines, which lay fallow for the next two centuries. 🐟 Soon after his arrival in Taxco, Spratling, motivated by his desire to encourage the community's artistic spirit and by his own creative drive, decided to revive the mines. At that time the Mexicans were interested only in making gold jewelry, usually filigree work. The only silver objects being made were in the Spanish colonial style: platters, candlesticks, and the like. And the only silver work that could be called creative and innovative had been done in the twenties by another American, Frederick Davis, in Mexico City. 🐟 Spratling had many new ideas for designs for jewelry, but there was no one in Taxco to execute them. Though there were goldsmiths in the nearby village of Iguala, they believed it was beneath their dignity to work with silver. One of them, Artemio Navarrete, stated: "At the time, rather than buying silver from a bank, one-peso silver coins were smelted to make artworks. Coins were minted from .925 sterling silver. Don Guillermo visited my small workshop in Iguala and ordered a silver ring, which I was to make following his design and using a stone he provided. Later, he

placed other orders that I made following his designs, ornamenting the articles with Grecian frets and using the stones, generally jade or onyx, which were then found in the area." 🐟 Spratling maintained that "I've always had the conviction that certain materials have the right to be worked in a given community because they are native to that area and the work of the designer is to utilize these materials and to dignify them." 🐟 With charm and money, Spratling persuaded Navarrete to come to Taxco to work for him, and soon he added more silversmiths to his payroll, and even tinsmiths, carpenters, and an ironsmith. 🐟 "We were called *los zorros,* the foxes," says one apprentice, Antonio Castillo, who eventually went on to make his own name as a silversmith, as did so many of Spratling's protégés. "We would spend thirty days just sweeping the floors, then another month making the beads, the wires, then learning how to solder, to hammer the silver. In those days, there was not a blowtorch, only a mouth blower. Finally we learned to make the designs and to produce a finished piece of jewelry." 🐟 "The Taller de Las Delicias," as Spratling named his workshop, caught on

immediately, and the new highway from Mexico City to Acapulco by way of Taxco brought hundreds of tourists to buy his wares. The operation expanded until he had four hundred people working for him. And as Spratling prospered, so did the town. People came from all over to visit the colorful unofficial mayor of Taxco—people as diverse as Leon Trotsky, Clare Booth Luce, and Errol Flynn—and to see his latest creations. (Among them, he claimed, with inordinate pride, was the tequila and lime juice drink, the margarita.) An important archaeological discovery was made in Oaxaca in 1932, when Tomb Number 7 in Monte Alban was opened. It was filled with jewelry from the ancient Mixtec and Zapotec civilizations, and Spratling soon created abstract versions of many of these designs. Soon Spratling-designed pieces were selling in stores such as Saks Fifth Avenue, Tiffany, and Neiman-Marcus. Writer Mary Anita Loos recalls: "Other shops cropped up around the main plaza, and hotels flourished and Bill even built a hotel, the Rancho Telva, which in turn had become *the* place in Mexico where everyone went to shop and spend the night on the way to Acapulco. Bill's grey eyes sparkled and he exuded warmth and enthusiasm as he talked about art and archaeology and life, and everyone wanted to meet him and be near him." Spratling, to get away from his

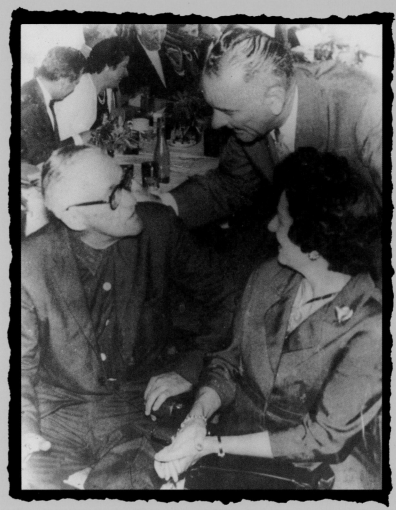

Spratling (left) with Lyndon and Ladybird Johnson circa 1960's.

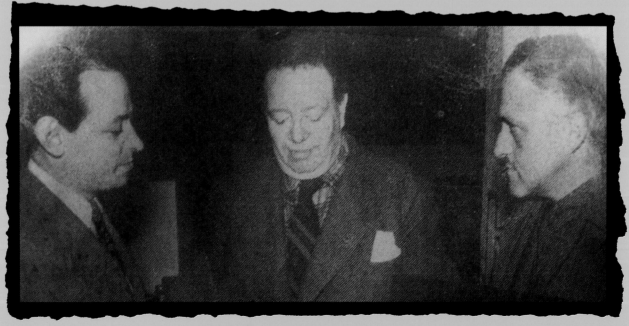

*Richard Gump, Diego Rivera, and Spratling admire a pin Spratling created
for Gump's of San Francisco in 1942.*

new celebrity, built a ranch house fifteen minutes from Taxco. There he lived his busy "disorderly, ordered life" in the midst of a veritable zoo. At one point, he had an ocelot, macaws, deer, peccaries, a type of boa constrictor called a mazcoa, a pair of otters, seven Siamese cats, and twenty-three Great Danes. Around his house he planted guava and orange trees, mangos, and eight types of banana trees. Always an adventurer, Spratling lived life to the hilt. When he went to Europe it was by zeppelin, just before the *Hindenburg* disaster. Once, knowing nothing about sailing, he bought a small boat in Santa Monica, took two days of instruction, and proceeded to sail the craft, alone except for two seasick cats, to the distant coast of Acapulco. One morning, on the way, he tried to spear a huge shark with his boat hook and fell overboard, every lone sailor's nightmare. Luckily, the boat hook was attached to a cleat by a stout fishing line, and he managed to haul himself back to the boat and heave himself in. It took him forty-three days to finally make the Acapulco harbor. His friends had long since given him up for lost. His friend Mary Anita Loos says: "He always sailed with a *furor!*" He later bought a yacht, but Bill's great delight was his tiny airplane, an Ercoupe, which he flew everywhere. He had many near misses in it. Once, while taking off from a pasture near Taxco, his landing gear

clipped a bull and killed it instantly. "I should have been awarded the animal's ears," he said later. "No matador ever made a quicker kill." Another time he made the long flight to Nassau via Havana for his friend Nancy Oakes's wedding. On the return trip he ran into storms, was blown off course, and was reported dead by the Coast Guard and subsequently in the newspapers. On another occasion, when he ran out of fuel, he was forced to land in a mountainous clearing and the plane flipped over at the end of the runway. Spectators pulled him from the plane and were horrified to see his head streaming with red. However, the "blood" turned out to be from a box of strawberries he was taking to a friend. In true Spratling fashion, he managed to get some gasoline, right the plane, and continue on his way. Later, in 1948, he was asked by President Eisenhower to do for Alaskan Eskimos what he had accomplished for Mexican Indians, i.e., show them how to develop their own arts and handicrafts. He agreed, and flew his tiny plane from Taxco all the way to Fairbanks, Alaska, a flight fraught with danger due to violent weather. There were many delays and detours, but he and the plane remained intact both going and coming. He designed and produced some two hundred prototypes for the Alaskans, based on indigenous traditions and using materials

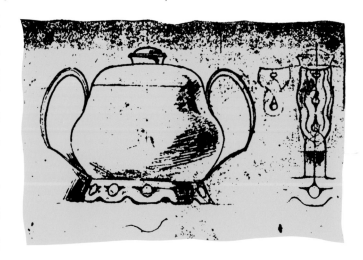

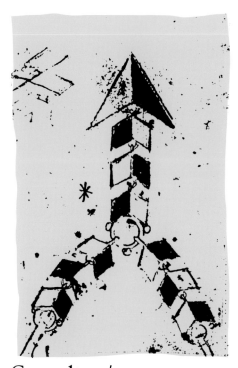

native to Alaska, such as shell, ivory, baleen, wood—and, of course, silver. Spratling brought several Eskimos back to Taxco to learn silversmithing from the Mexicans. They then returned to Alaska to teach others. Recently, while in Alaska, I saw several contemporary wood-and-silver pieces that looked as if they had been executed by Spratling himself. Spratling's prototypes were subsequently exhibited to acclaim at the New York Museum of Modern Art. Toni Lesser Wolf wrote in *Metalsmith*: "Spratling's intensive study of less convoluted Alaskan Indian motifs greatly influenced his later style in Mexico, which became simpler and less South American, relying less on borrowed Aztec, Mayan, or Spanish motifs and more on universal non-representational forms." A less fortunate episode than his extraordinary Alaskan round-trip flight was the last of his twenty-three hundred round-trip flights from Taxco to Mexico City. "The cabin was loaded up to the plexiglass top with some ebony and silver bowls for my friend John Huston," he wrote in his autobiography. "I had promised to have breakfast with him at the Bamer Hotel in Mexico at eight-thirty. Leaving Iguala, where the smokes of a thousand breakfasts were slowly rising over the tamarinds and red-tile roofs, I climbed as usual on a five-degree-east compass course, steadily across the mountains and valleys

William Spratling circa 1960's.

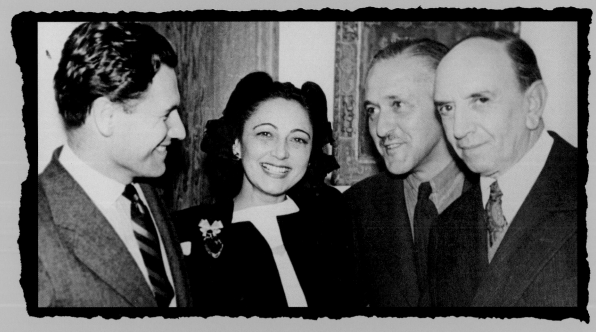

Nelson Rockefeller, Rosa Covarrubias, William Spratling and Roberto Montenegro
pose during a party at the Covarrubias home in 1930's.

of Morelos, looking down to make out the vast ruins of Xochicalco, passing Cuernavaca at ten thousand feet in the bright clear morning air of the south, and then over the summits of the pass by Tres Marías. The Valley of Mexico, just ahead, was a large bowl of milk." All of a sudden he was engulfed in a huge cloud mass, was tossed around like a rubber ball for thirty-five minutes, and then was slammed into a mountaintop. The plane was destroyed, but he, unbelievably, was unscathed. After spending the bitterly cold night in the wrecked aircraft, he climbed down the mountain to safety the next day. He had no such luck in 1967. On August 7 he was making an early-morning routine trip to Mexico City when his car crashed into a tree that a storm had blown across the road in the night. His chest was crushed, and he was taken to a nearby hospital. He had only time to ask for a cup of coffee before he died. All of Taxco was draped in mourning. His workers took turns carrying the coffin to the little cemetery, and thousands of people crowded the ceremony. The American ambassador, Fulton Freeman, spoke, saying: "All of the residents of this lovely city are completely aware of Bill's great contribution, economic and social, and with them we share the loss of the best-known and probably the best-loved American in all Mexico."

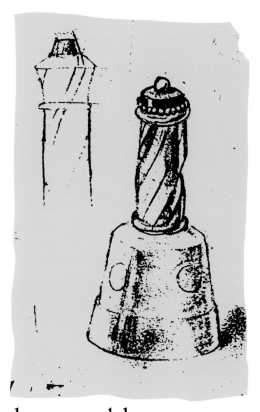

Elizabeth Anderson, his friend of long standing and the widow of writer Sherwood Anderson, wrote of the two-day official mourning: "The town seemed to be in a state of shock. People stood around in little groups, not talking, just standing together as if taking comfort in the mere presence of others. Large blue bows of ribbons were hung on all the doors of the shops and houses . . . the street sign for the Calle de Guillermo Spratling had been draped in black. In front of the church there were great banks of flowers. Enormous heavy wheels of flowers, five feet tall, had been propped up against the iron fence." Some time later, the ranch and the silver factory were sold to Alberto Ulrich, a chemical engineer and art collector from Europe, who vowed to keep the quality of silverwork up to Bill Spratling's standards. My most recent visit to Taxco was more than ten years after Spratling's death. I was invited by the Mexican government to the annual week-long Taxco Silver Fair as one of the three judges, the other two being the president of Tiffany and Co. in New York and the Queen of England's jeweler in London. The delightful stage set of a town seemed much the same as when I'd first seen it, almost forty years before: the same international characters at Paco's bar, the same swarm of tourists in the

square in front of the lovely cathedral. Spratling is still very much a living presence there; as we judges looked over room after room of the silver objects entered in the various prize categories, we felt that he was standing behind us, looking over our shoulders, and perhaps clucking and quarreling with our choices. At one end of the plaza is the Calle Guillermo Spratling with its bust of Spratling, and just behind the Santa Prisca Cathedral is the William Spratling Museum, filled with outstanding pieces from his pre-Columbian art collection, which he left to the city in his will. (He also donated 189 pieces to the University of Mexico and 92 pieces to the Museum of Anthropology in Mexico City.) Distressingly, there is not one piece of Spratling's silverwork on view in the museum. Spratling's greatest legacy is the silver shops that abound and flourish in the town of Taxco and throughout Mexico. Unfortunately, the quality of the designs and workmanship is seldom up to Spratling's high standards: so much is repetitive, commonplace, prettified, and pedestrian. To see his designs wrought in silver is to experience the absolute beauty of the metal as fashioned by the hand of genius. Virtually everything in the world was inspiration for Spratling: astrological symbols, mythological animals, leafage, shells, and Jazz Age

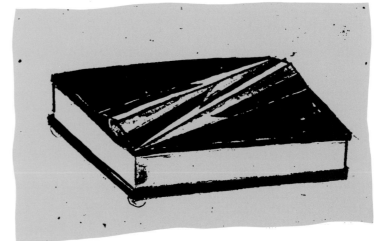

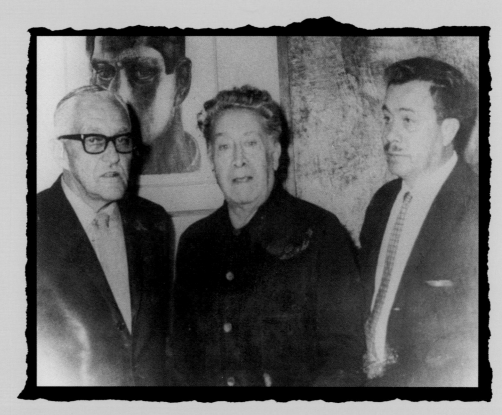

William Spratling (left), with artist David A. Siqueiros (center) and a friend.
Spratling stands before his own portrait, painted by Siqueiros.

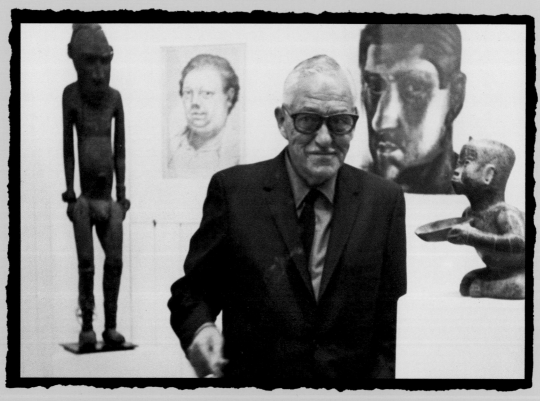

William Spratling at the Otis Art Institute,
1965, during exhibition entitled "The World of William Spratling"
The portrait of Spratling to his left was painted by David Siqueiros.

motifs. He was influenced by the surrealists of Europe and the peons of Mexico; by the Tutankhamen treasures discovered in Luxor in 1925 and by the 1932 discoveries of the Mixtec and Zapotec treasures in Monte Alban in Oaxaca; by mythical unicorns as well as the pet boa constrictor in his backyard. The jaguar in the jungle, the hummingbird, and the lizard all found their way into his designs. He was in love with life, but it only truly existed for him when it was interpreted in silver. One of Spratling's longtime craftsmen said the master always urged him to get rid of trivial decoration, saying of a new design: "Don't make it *prettier*. Always keep it simple." A fitting epitaph for a great silver-smith and jeweler.

Barnaby Conrad
Carpinteria, California
1990

PLATES

Brooch
Sterling

$2'' (l) by 2 {}^{3}/_{4}'' (w)$

Private Collection

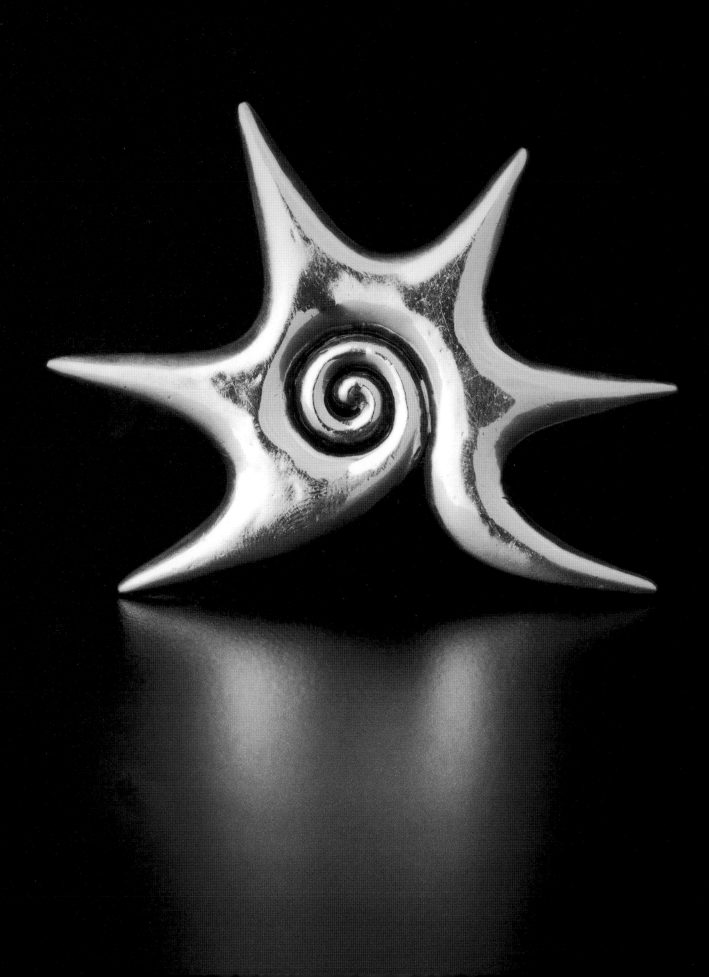

Tray

Sterling

$^3/_4''$ (h) by $13''$ (l) by $11''$ (w)

Collection of Sandraline Cederwall

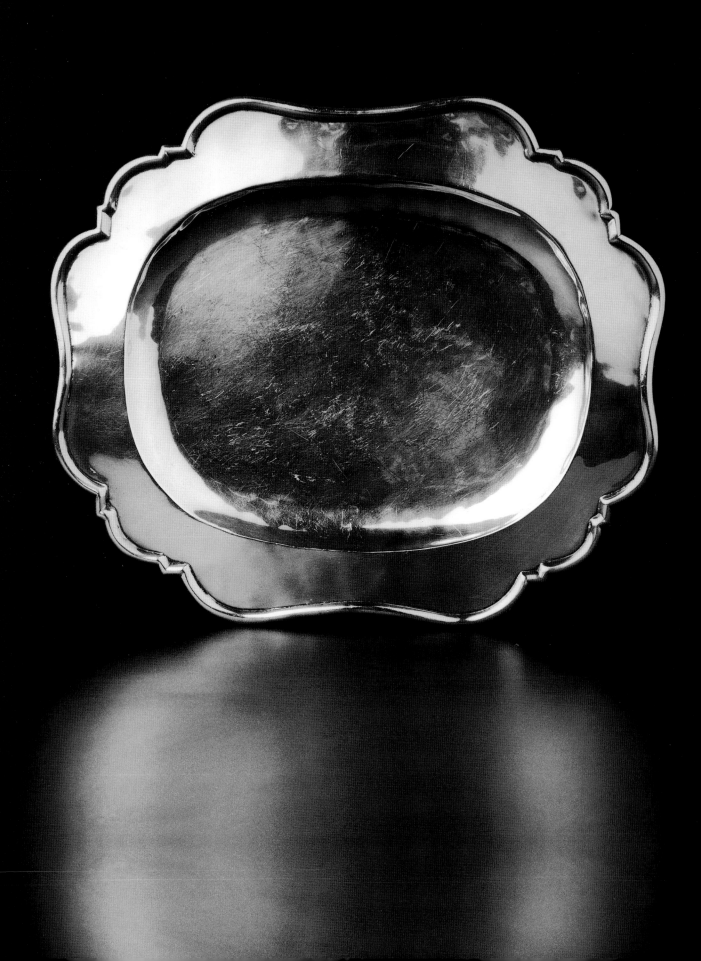

Necklace
Sterling and Gold Wash

Chain: 17$^1/_2$" (including clasp) by $^5/_8$" to $^3/_4$" (w)
Pendant: 2$^1/_2$" (l) by 3$^3/_8$" (w)

Collection of David and Carol Boss

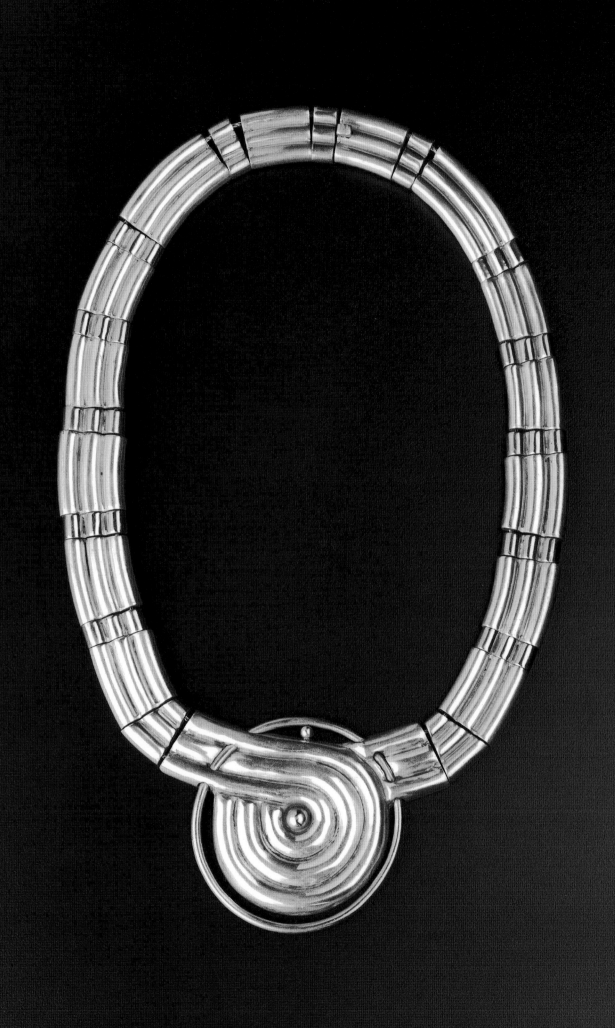

Pie Server
Sterling

$1^{3}/_{8}"\ (h)\ by\ 10^{1}/_{2}"\ (l)\ by\ 2^{3}/_{4}"\ (w)$

Collection of Ande and Peter Rooney

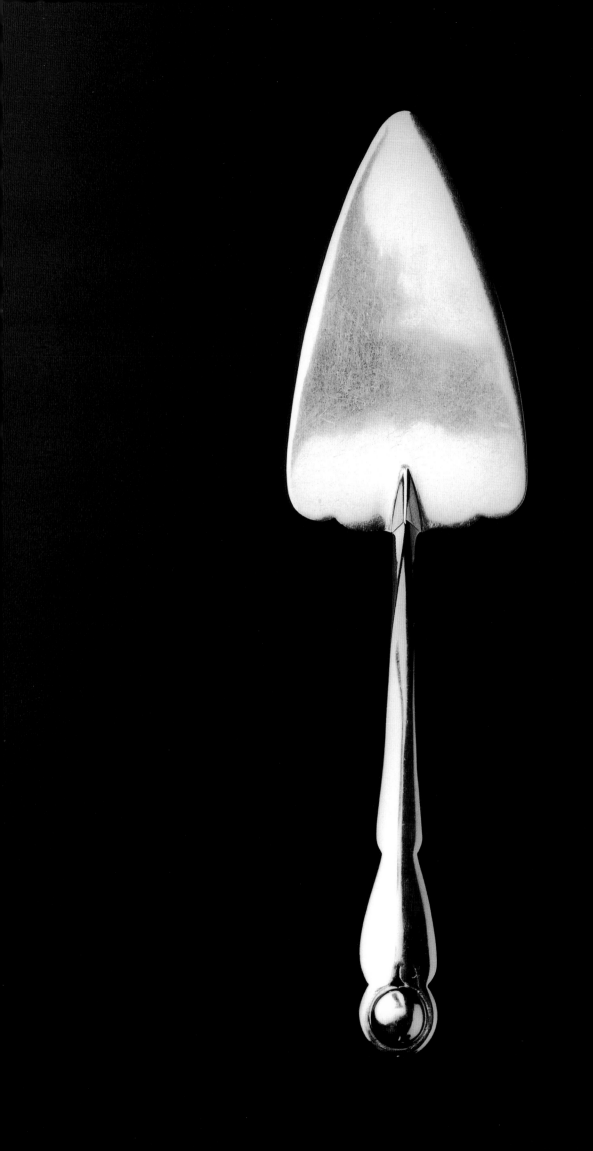

Teapot
Sterling

7" (h) by 8¹/₄" (l) (including spout and handle) by 4" (w)

Collection of Sandraline Cederwall

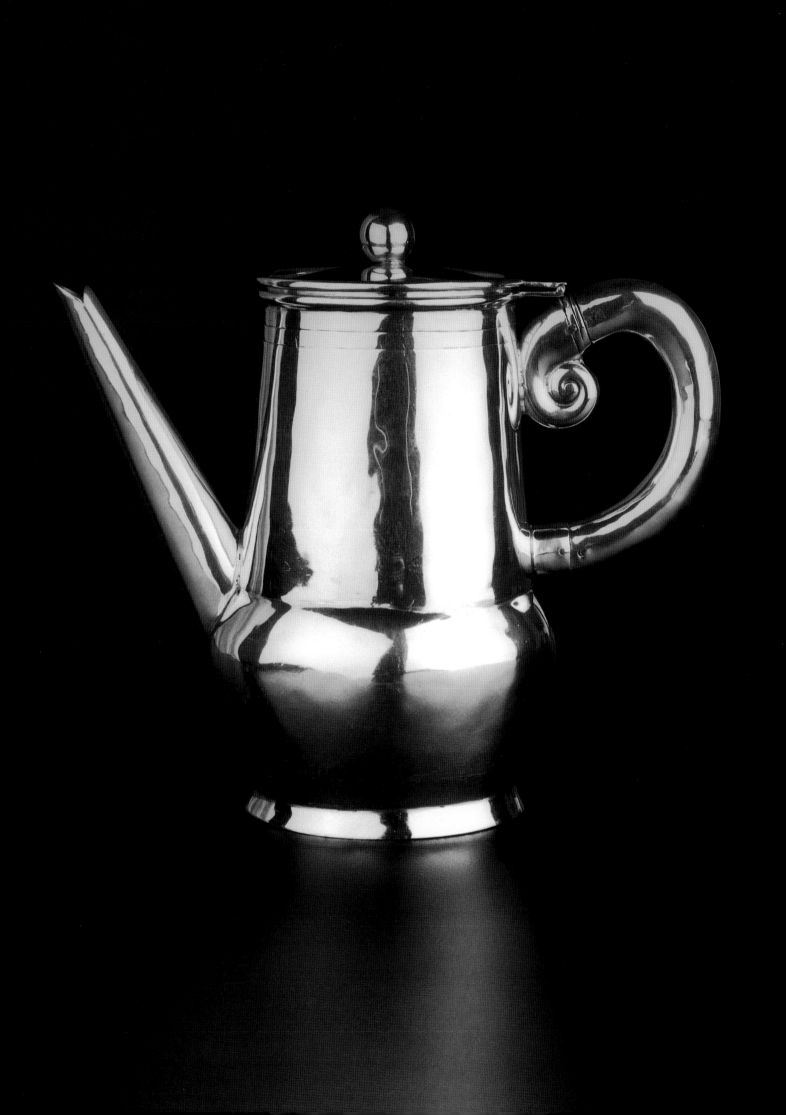

Necklace
Sterling and Tortoiseshell

Chain: 16"
Pendant: 2¹/₂" (l) by 2³/₄" (w)

Collection of Cederwall Fine Art

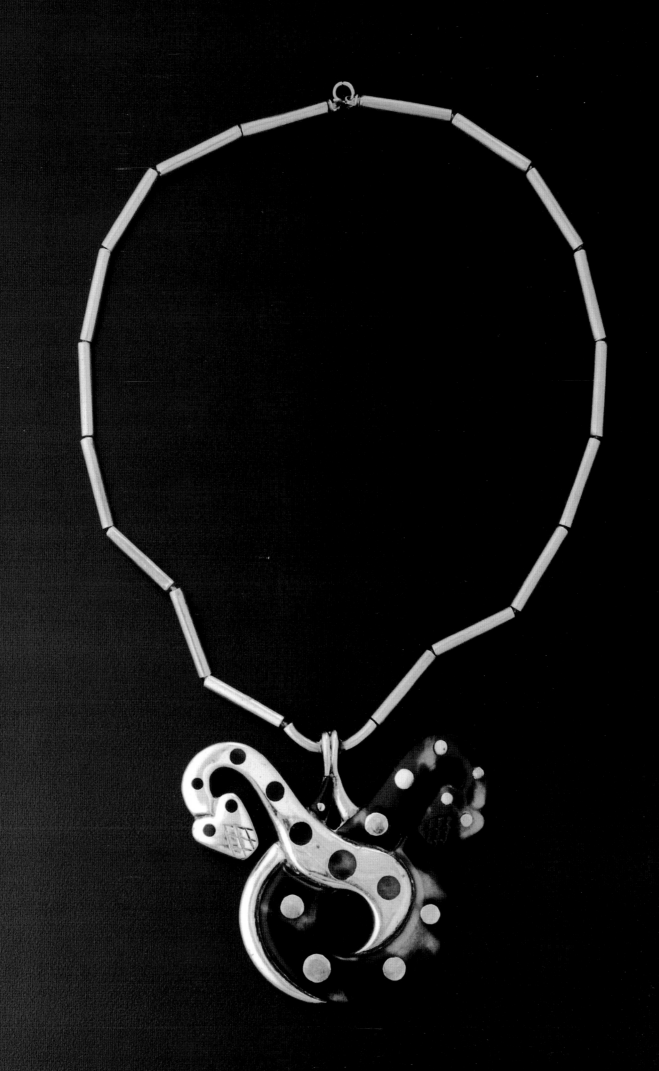

Tea Strainer
980 Silver

$^1/_2$" (h) by 5" (l) by 2$^1/_4$" (w)

Collection of John H. Garzoli

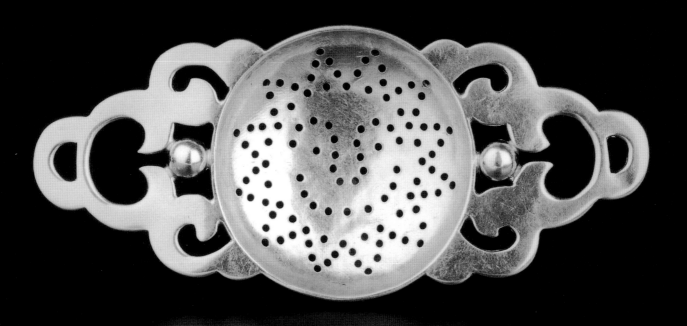

Chessboard
Sterling and Rosewood

$^3/_4$" (h) by 13$^3/_8$" (l) by 13$^1/_2$" (w)

Collection of Phyllis and David Goddard

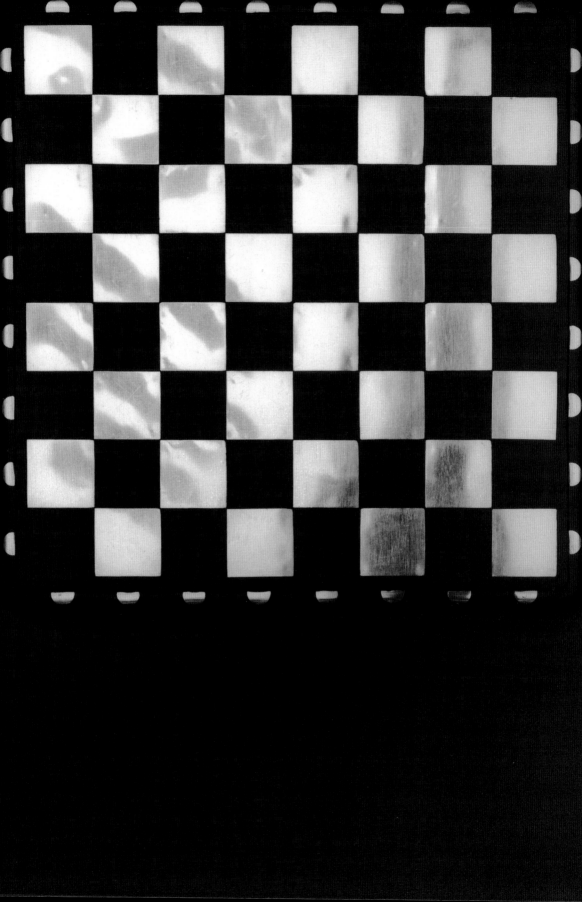

Bookends
Sterling

Hand: 6³/₄" (l) by 3³/₄" (w)
Base: 5" (l) by 3¹/₄" (w)

Collection of Sandraline Cederwall

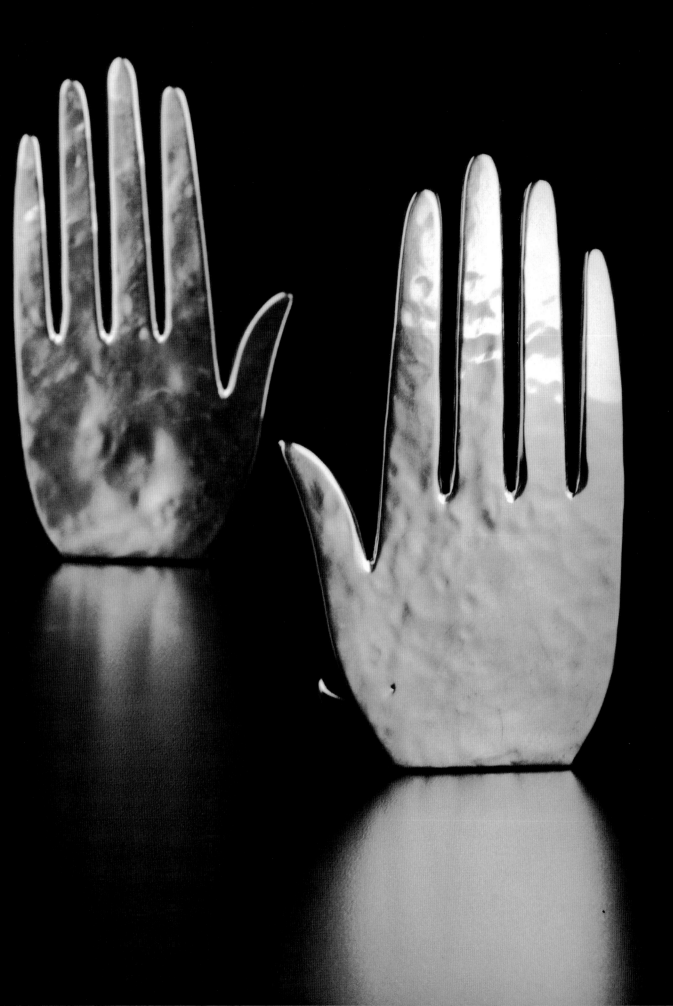

Coffee and Tea Set

Sterling and Rosewood

Coffeepot: 8$^{1}/_{4}$" (h) by 9$^{1}/_{2}$" (l) (including spout and handle) by 5$^{1}/_{2}$" (w)
Teapot: 6" (h) by 10$^{1}/_{2}$" (l) (including spout and handle) by 4" (w)
Cream Pitcher: 3" (h) by 5$^{3}/_{8}$" (l) (including spout and handle) by 4" (w)
Sugar Bowl: 3$^{3}/_{4}$" (h) by 6" (l) (including handles) by 4" (w)

Collection of Phyllis and David Goddard

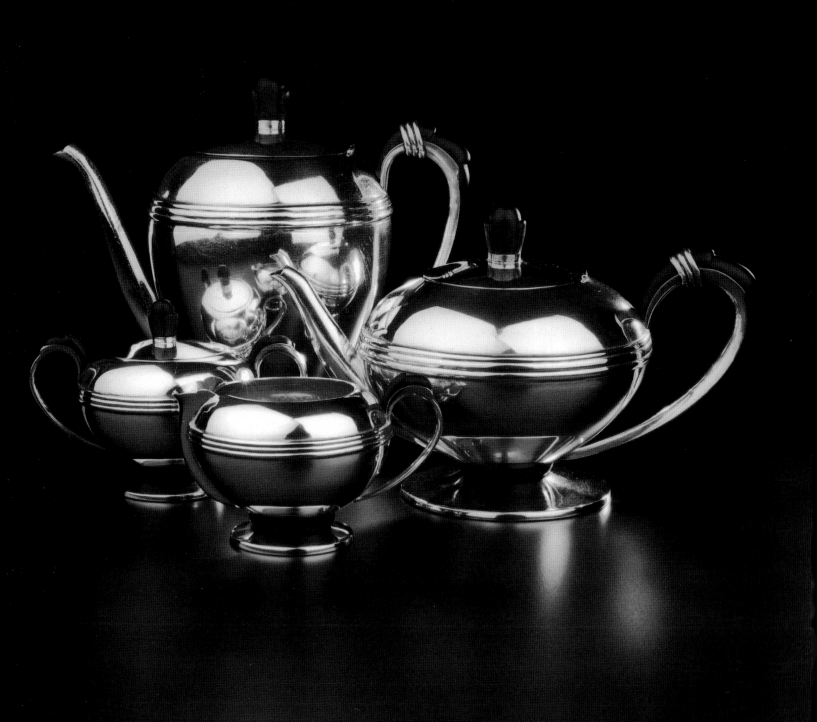

Necklace
980 Silver

Chains: 6¹/₂" to 7¹/₂" (l)
Pendant: 3³/₄" (l) by 3³/₄" (w)

Collection of Sandraline Cederwall

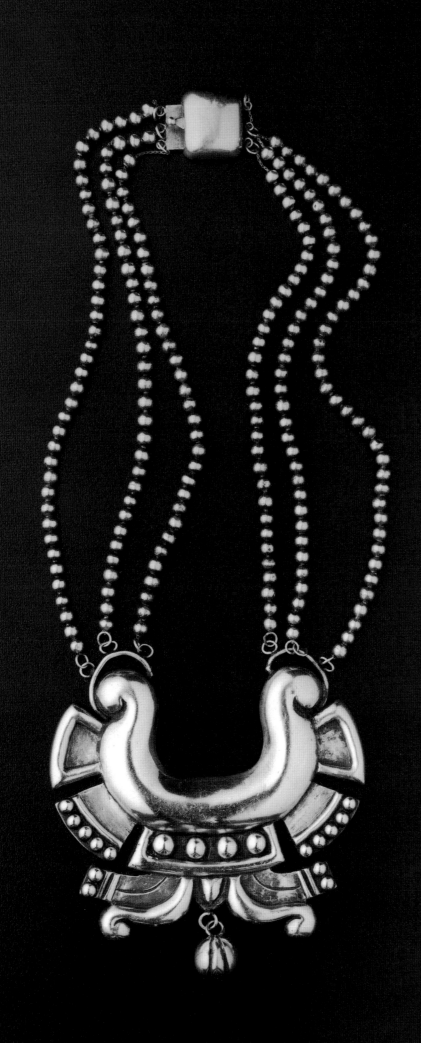

Pitcher
Sterling

$3\,^{1}/_{8}''\ (h)\ by\ 3\,^{3}/_{4}''\ (l)\ by\ 3''\ (w)$

Collection of Mary Anita Loos

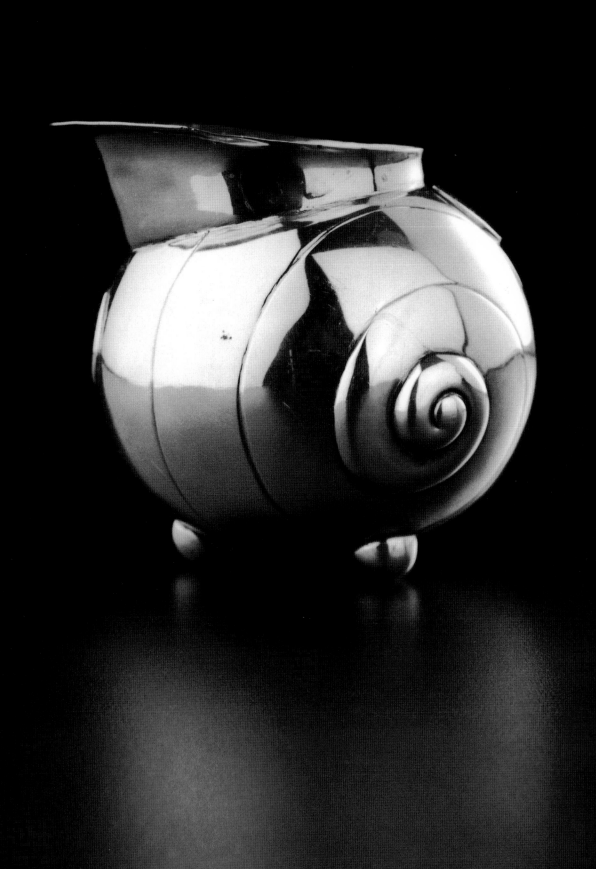

Bangles

(Bracelets)
980 Silver

$^3/_8$" *(w) by* $3^1/_4$" *(d)*

Private Collection

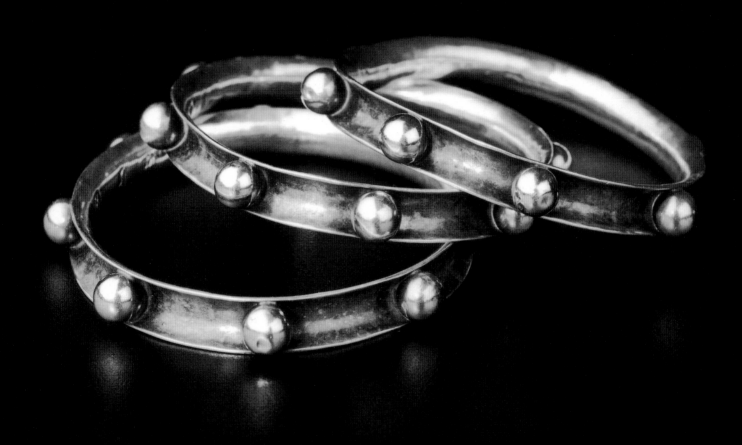

Necklace
980 Silver

Bib: 4¹/₂" (l) by 9" (w)
Chains: 3⁷/₈" and 3¹/₂"

Collection of Phyllis and David Goddard

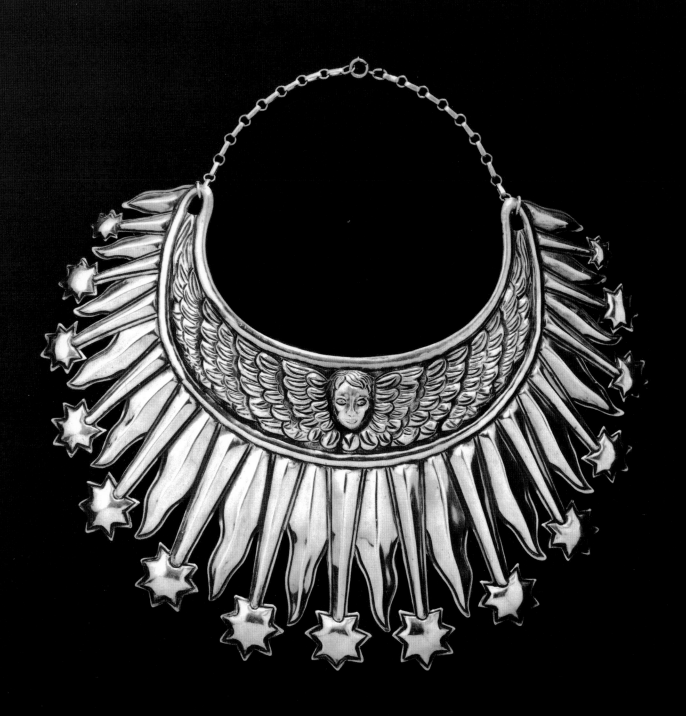

Box
Sterling and Gold Wash

$1^{1}/_{2}''$ *(h) by* $3^{5}/_{8}''$ *(l) by* $2^{3}/_{4}''$ *(w)*

Collection of John H. Garzoli

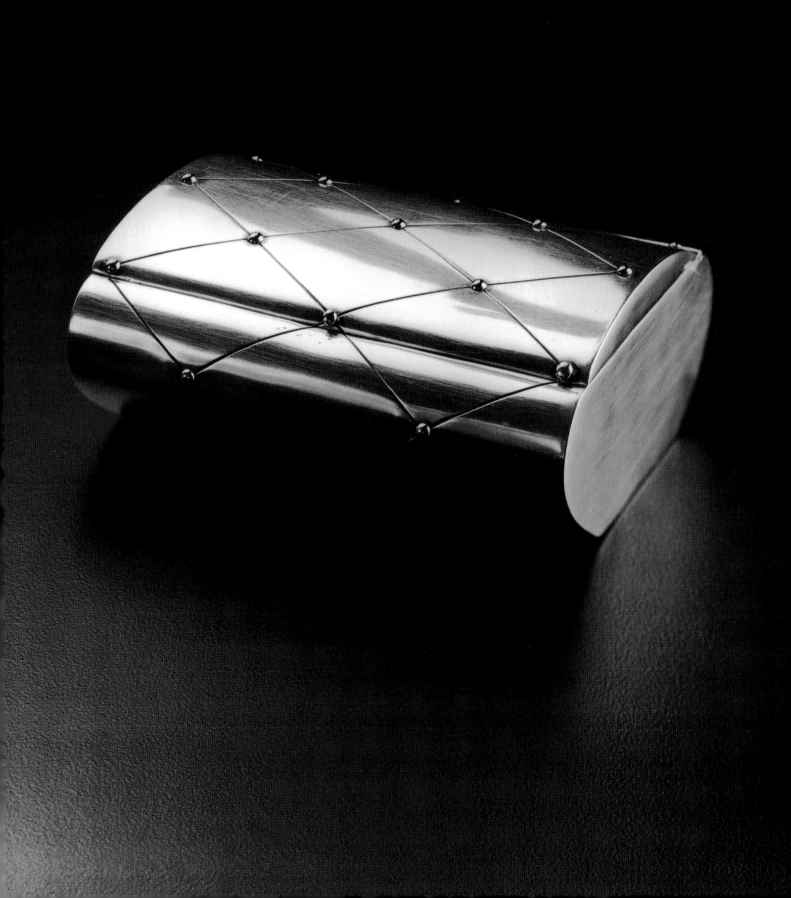

Coffee and Tea Set
Sterling and Ebony

Coffeepot: 8" (h) by 9¹/₂" (l) (including spout and handle) by 3³/₄" (w)
Mochapot: 5³/₄" (h) by 8" (l) (including spout and handle) by 3¹/₄" (w)
Teapot: 5¹/₂" (h) by 9" (l) (including spout and handle) by 4¹/₄" (w)
Cream Pitcher: 3" (h) by 5¹/₂" (l) (including spout and handle) by 3¹/₈" (w)
Sugar Bowl: 3" (h) x 6" (l) (including handles) by 3¹/₈" (w)
Tray: ³/₄" (h) by 17" (l) (including handles) by 13⁷/₈" (w)

Collection of Ande and Peter Rooney

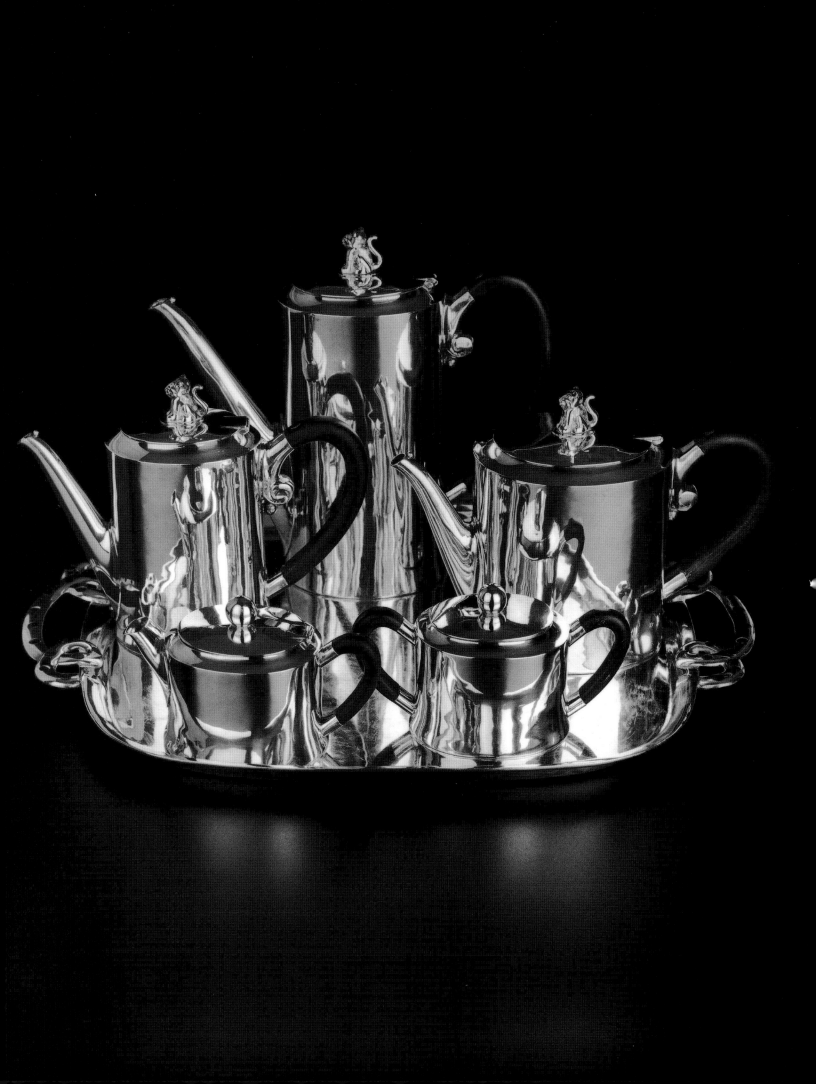

Necklace
Sterling and Copper

17" long
Fish: 1⁵/₈"
Cascabelles: 1"

Collection of Hodosh Family

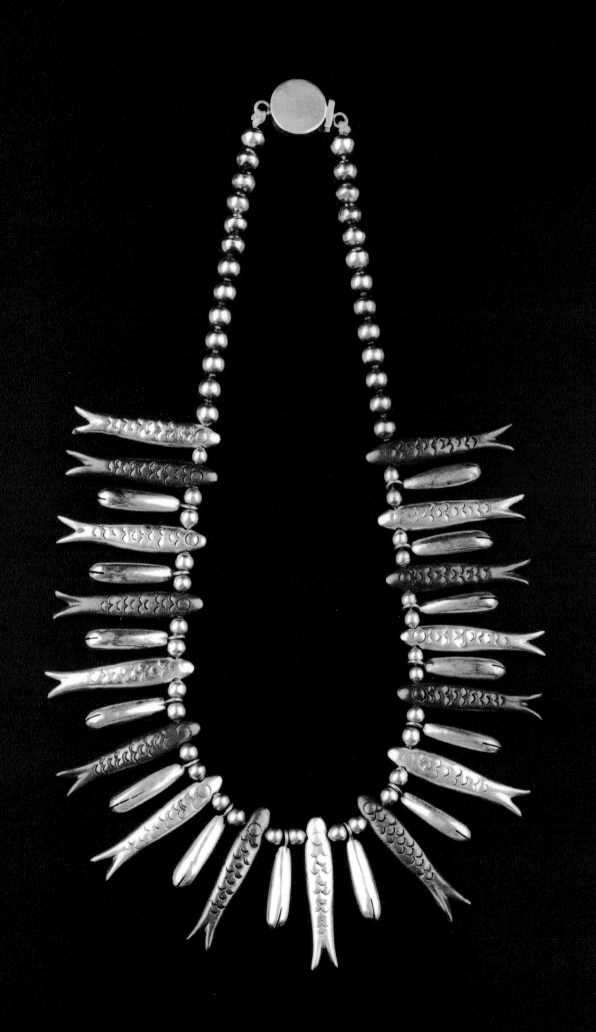

Box
980 Silver

$^3/_4"$ (*h*) *by* $1^7/_8"$ (*l*) *by* $1"$ (*w*)

Collection of Sandraline Cederwall

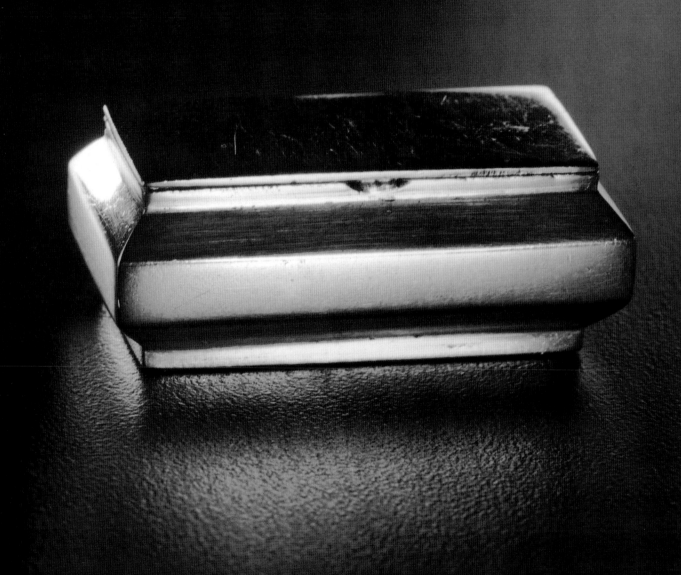

Tray

Sterling and Tortoiseshell

${}^{3}/_{4}"\ (h)\ by\ 8\,{}^{3}/_{4}"\ (l)\ by\ 6\,{}^{7}/_{8}"\ (w)$

Collection of Jean Hakes

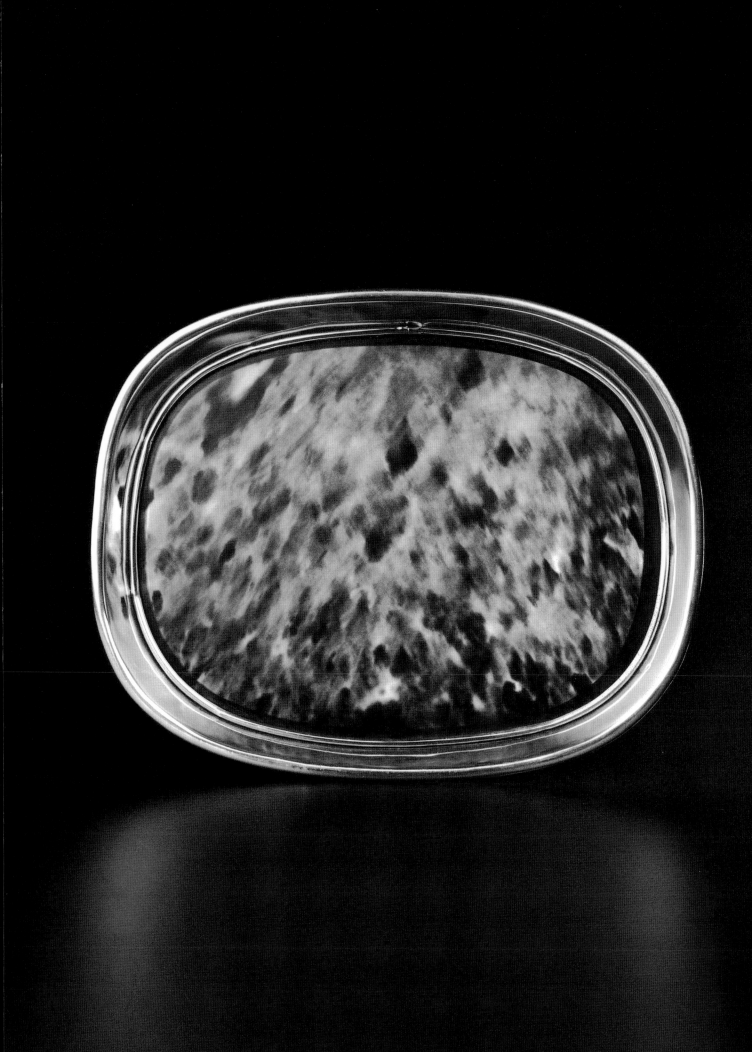

Brooch
Obsidian and 18k Gold

(no mark)

$1^{1}/_{4}$" (l) by $1^{1}/_{4}$" (w)

Collection of Sandraline Cederwall

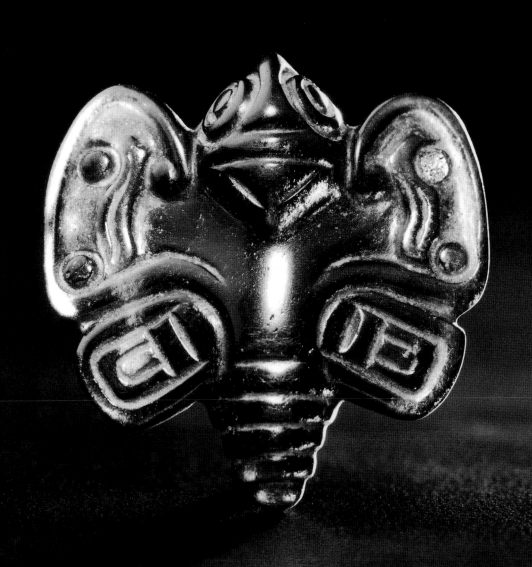

Brooch

Sterling and Turquoise

2" (l) by 2¹/₈" (w)

Collection of Jean Hakes

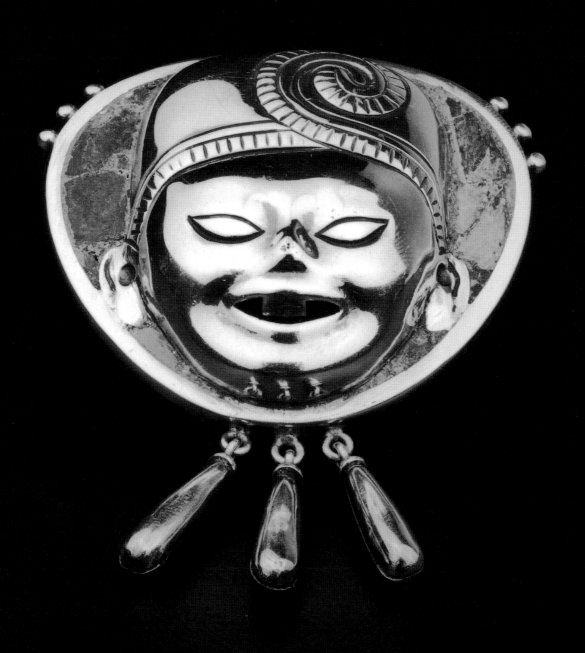

Candelabra
Sterling

7" (h) by 8³/₈" (l) on 4" x 4" square base

Collection of Ronald A. Belkin

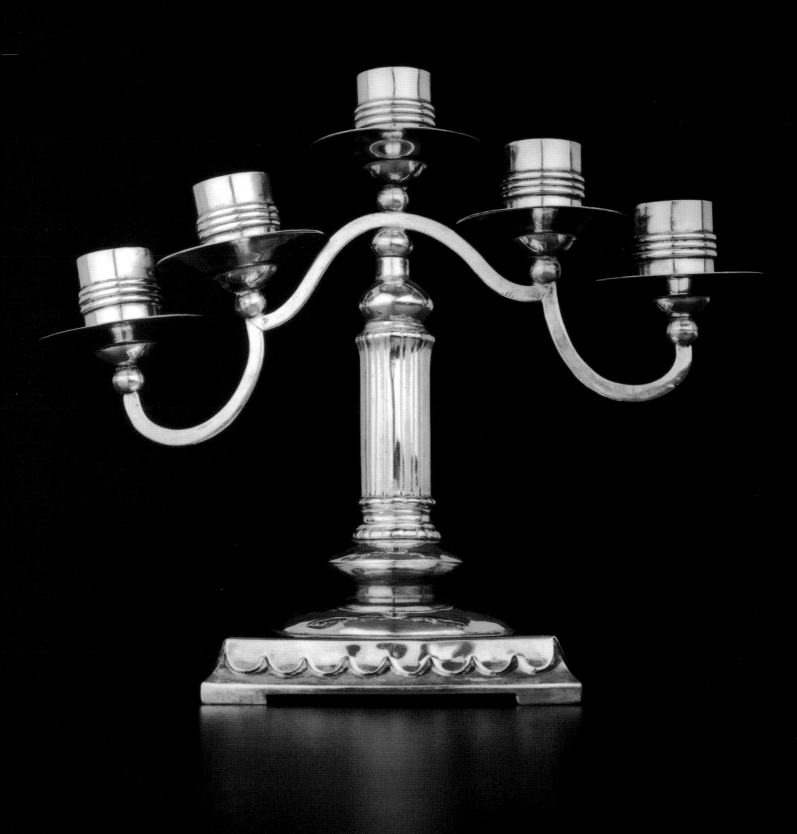

Brooch

Sterling and Amethyst

$2^{7}/_{8}$" (l) by $4^{5}/_{8}$" (w)

Collection of Jean Hakes

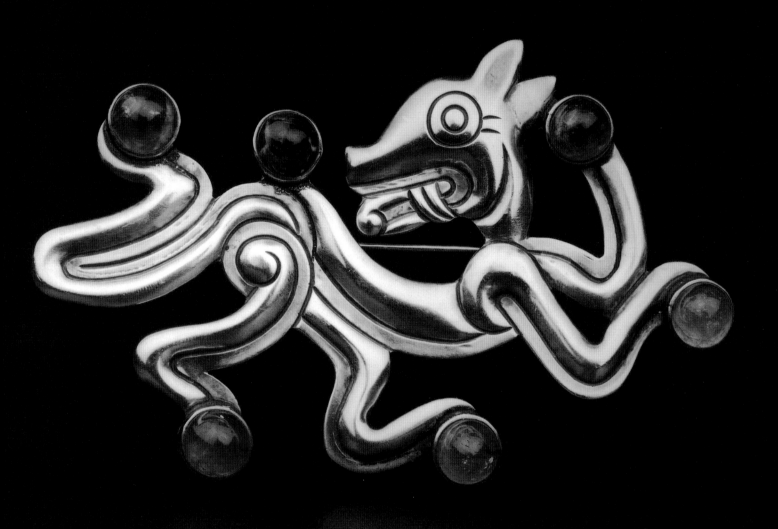

Bowl

Sterling

STERLING

$3\,^1/_8''\,(h)\,by\,6\,^3/_4''\,(d)$

Collection of Rhonda Harness

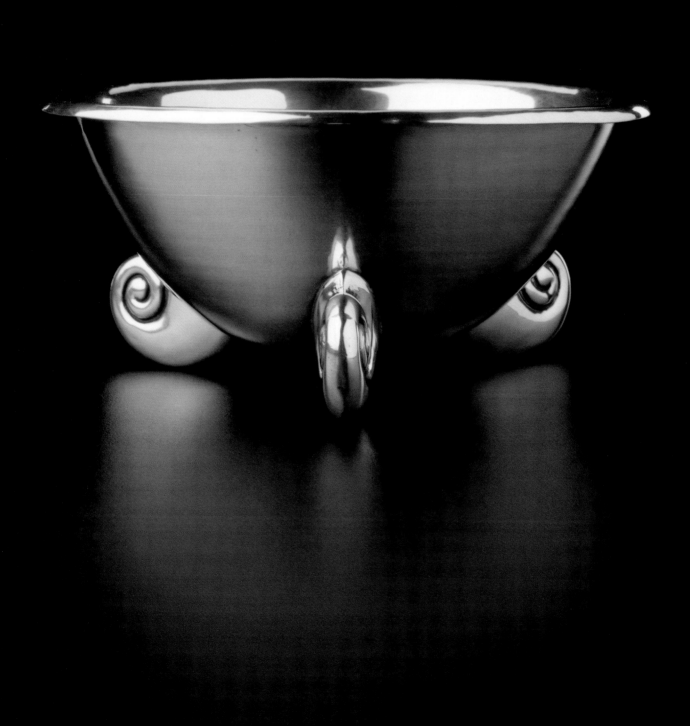

Knife
Sterling and Rosewood

$8" (l)$ *by* $1^3/_4" (w)$

Collection of Sandraline Cederwall

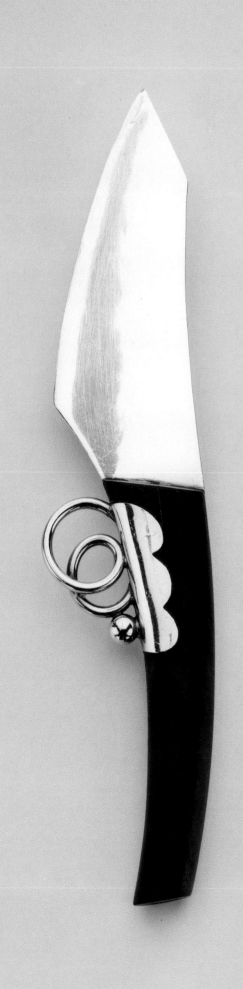

Spoon
Sterling

5" (l) by 1¼" (w)

Collection of Anni and Edward Forcum

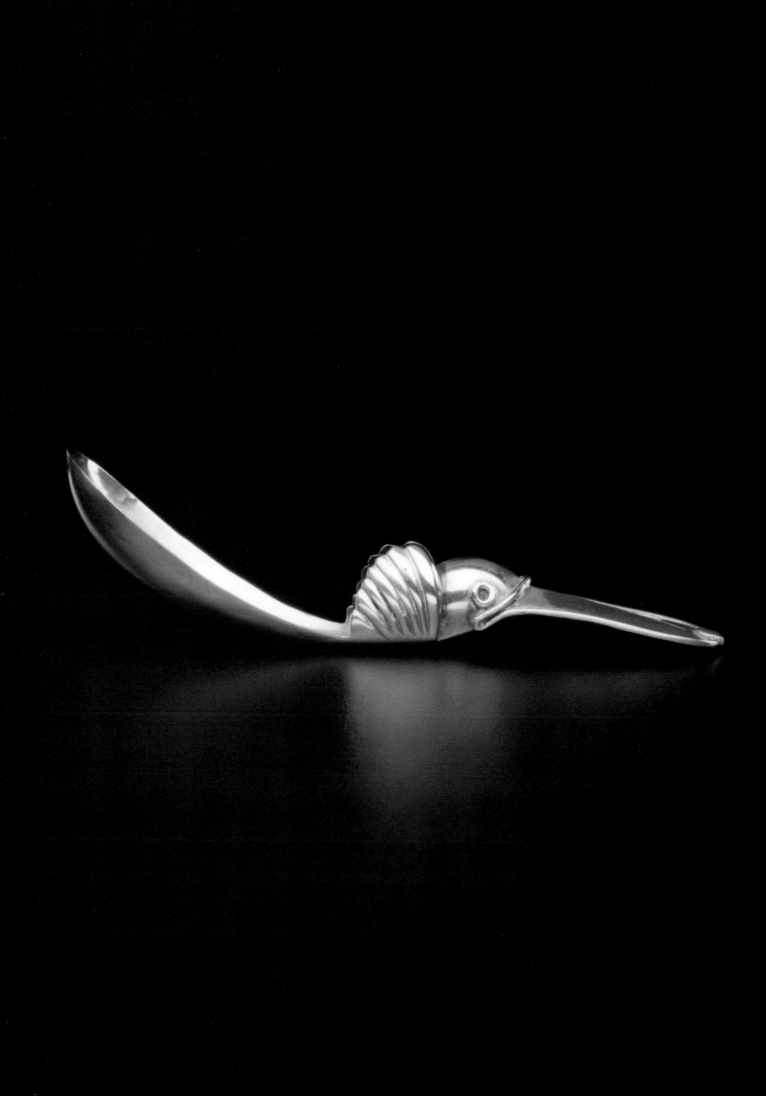

Pitcher
Sterling and Rosewood

6⁵/₈" (h) by 9¹/₄" (l) (includes handle) by 6¹/₄" (w)

Collection of John H. Garzoli

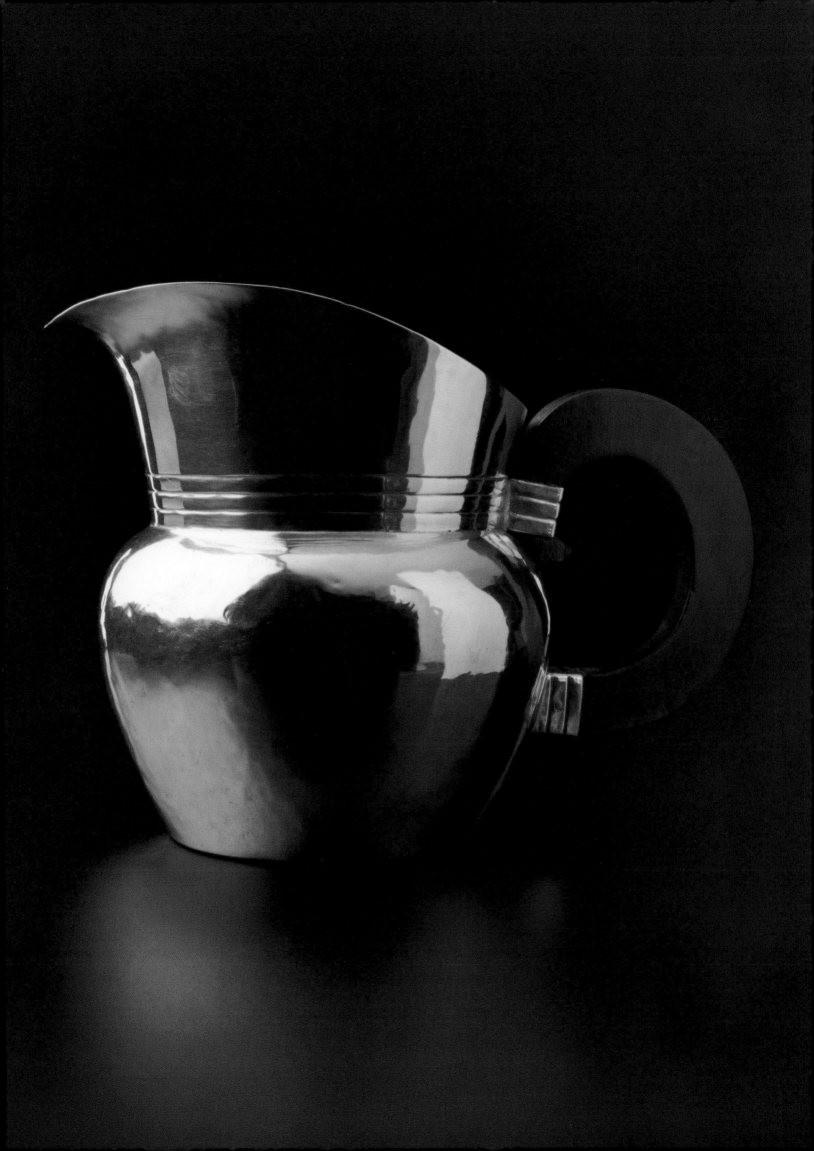

Necklace
18k Gold and Jade

Necklace: 21¹/₂" (l) (chain 10¹/₂", discs 11")
Discs: 1¹/₂" (d)

Private Collection

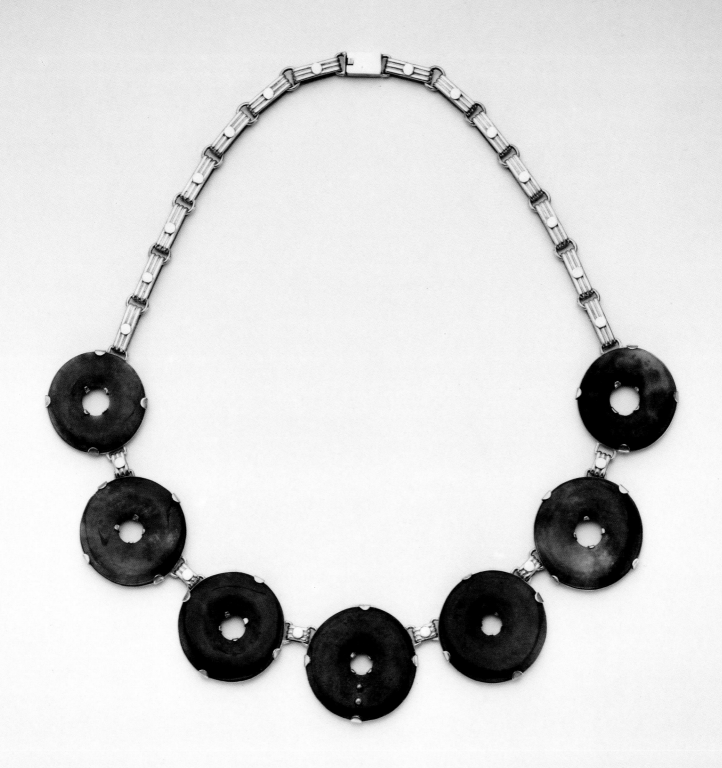

Earrings
Sterling and Abalone Shell

925

$1"$ (l) *by* $1\,^1/_8"$ (w)

Private Collection

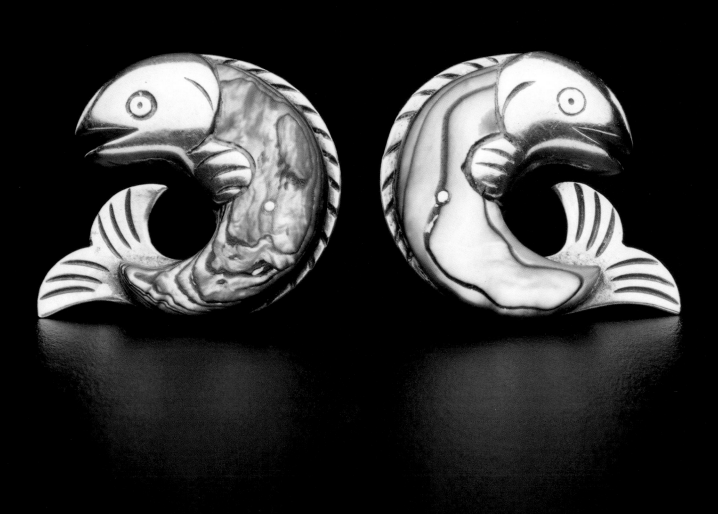

Box
Sterling and Tortoiseshell

$1\,^1/_{16}''$ (*h*) *by* $3\,^5/_8''$ (*l*) *by* $2\,^5/_8''$ (*w*)

Collection of Anni and Edward Forcum

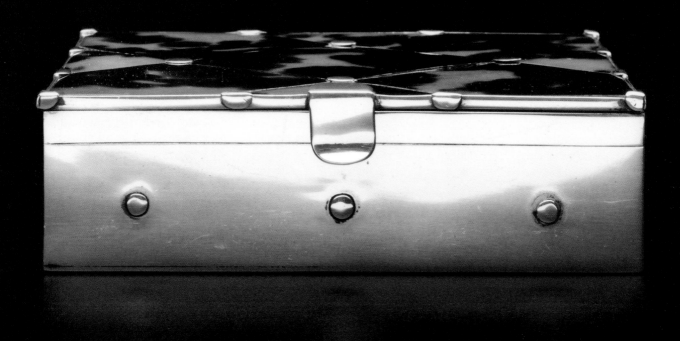

Bracelet
Sterling and Copper

9" (l) by 1" (w)

Collection of Anni and Edward Forcum

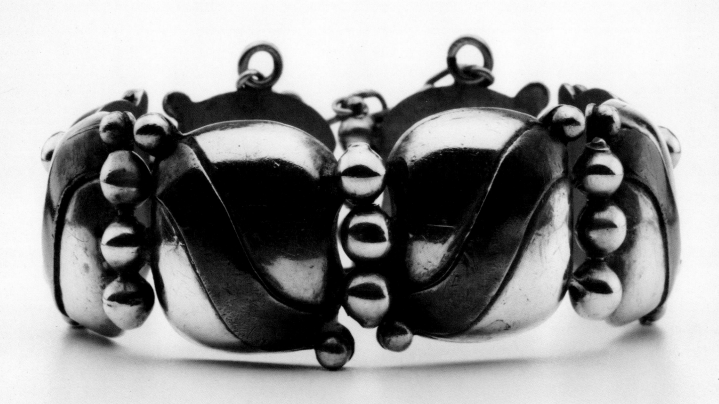

Spoon
Sterling

 STERLING

$5^1/_2$" (l) by $^7/_8$" (w)

Collection of Cederwall Fine Art

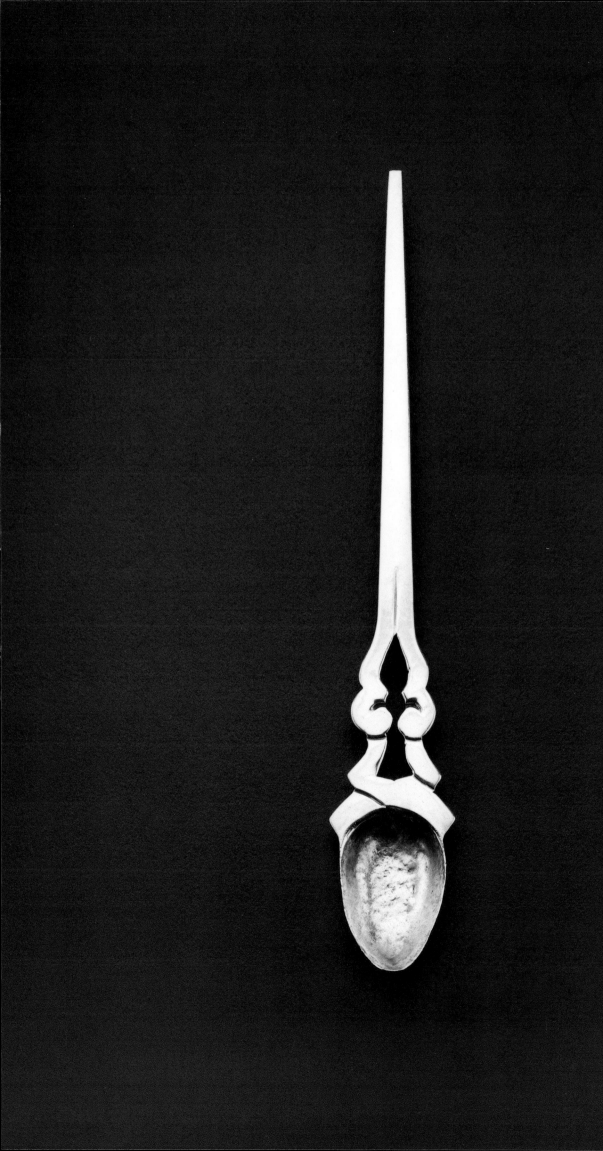

Tumblers

Sterling

$3^3/_8''$ (h) by $3^1/_8''$ (d)

Collection of Hal Riney and Sandraline Cederwall

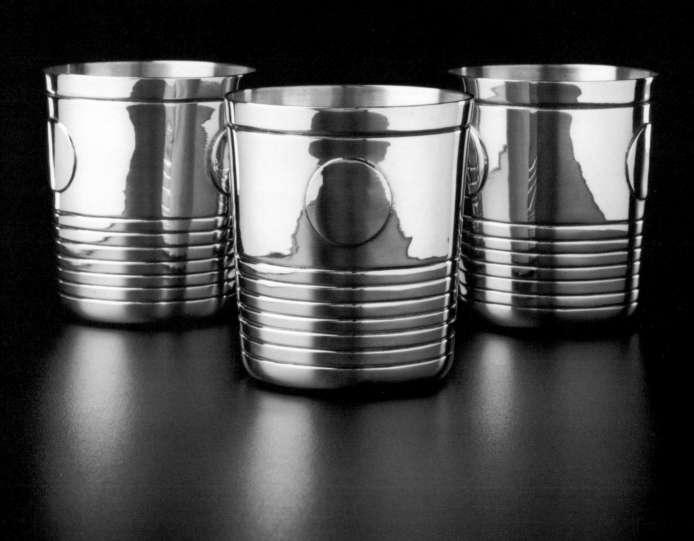

Dish

Sterling

$1/2''$ *(h) by* $6 1/2''$ *(d)*

Collection of Hal Riney

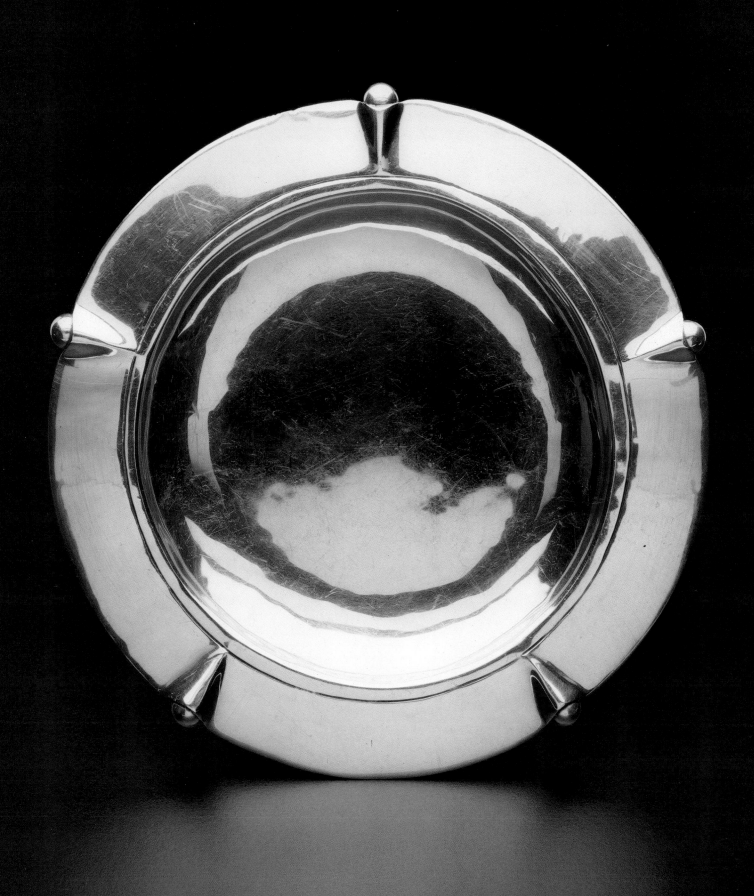

Bell

Sterling

5" (h) by 3¹/₄" (w)

Collection of Phyllis and David Goddard

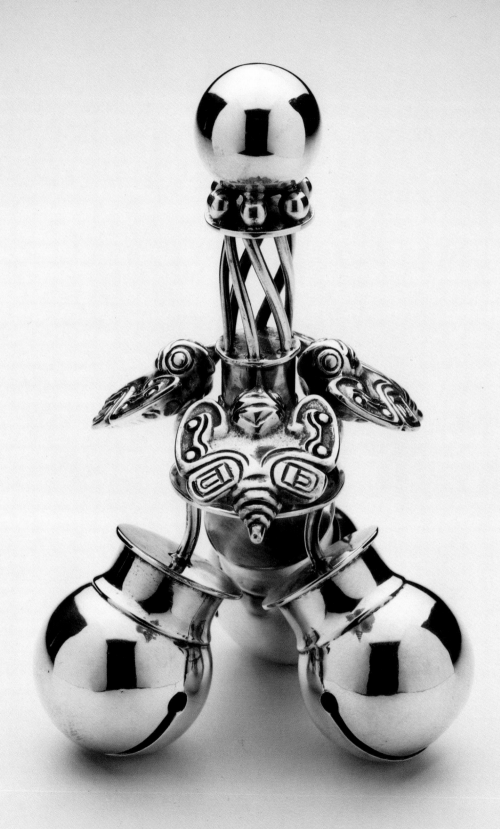

Child's Cup
Sterling

2⁷/₈" *(h) by* 3¹/₂" *(l) (includes handle) by* 2³/₈" *(d)*

Collection of Phyllis and David Goddard

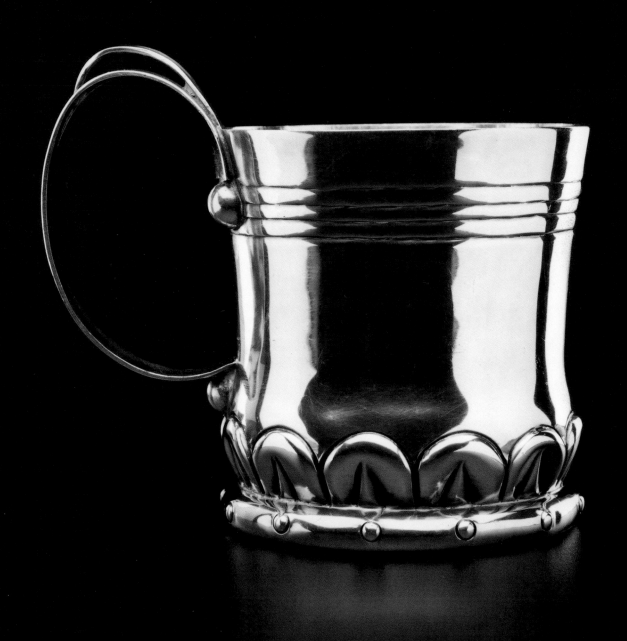

Bracelet
Sterling

$7^1/_2$" (l) by $^7/_8$" (w)

Collection of Anni and Edward Forcum

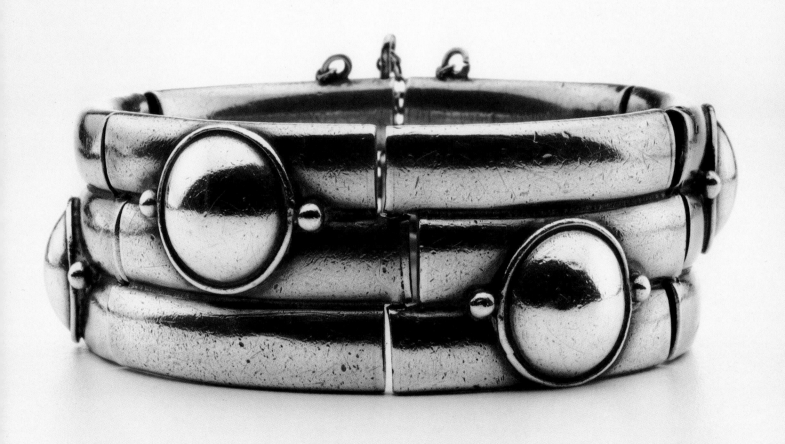

Pitcher

Sterling

 STERLING

7$\frac{1}{2}$" (h) by 8" (l) (includes handle) by 4$\frac{1}{4}$" (w)

Private Collection

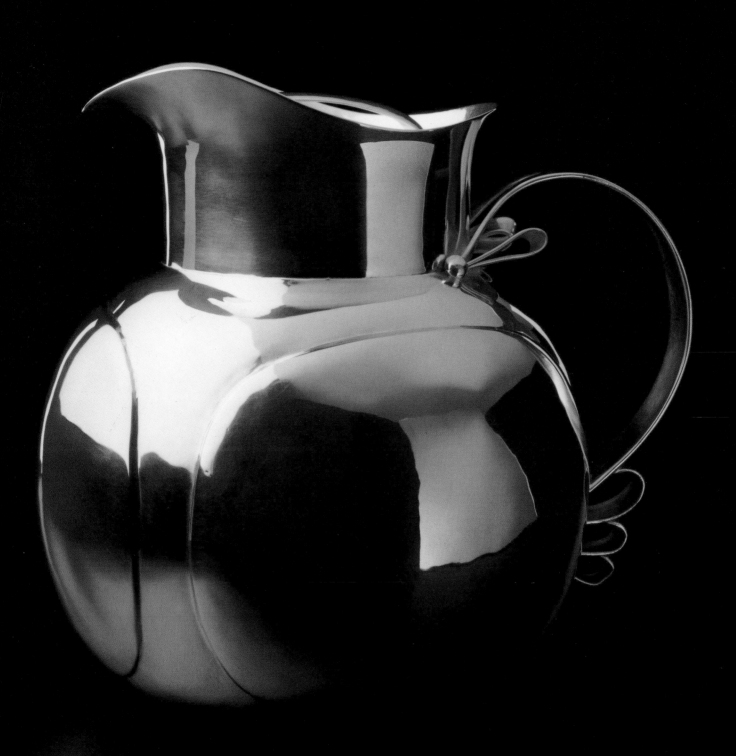

Brooch

980 Silver

$1^7/_8''$ (h) by $2^1/_8''$ (w)

Collection of Sandraline Cederwall

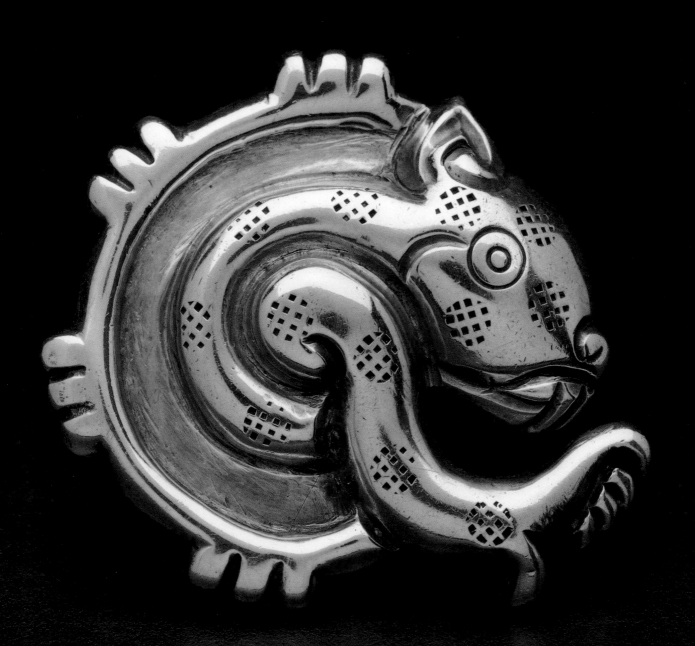

Bowl
Sterling and Amethyst

1³/₄" (h) by 11¹/₂" (d)

Collection of Phyllis and David Goddard

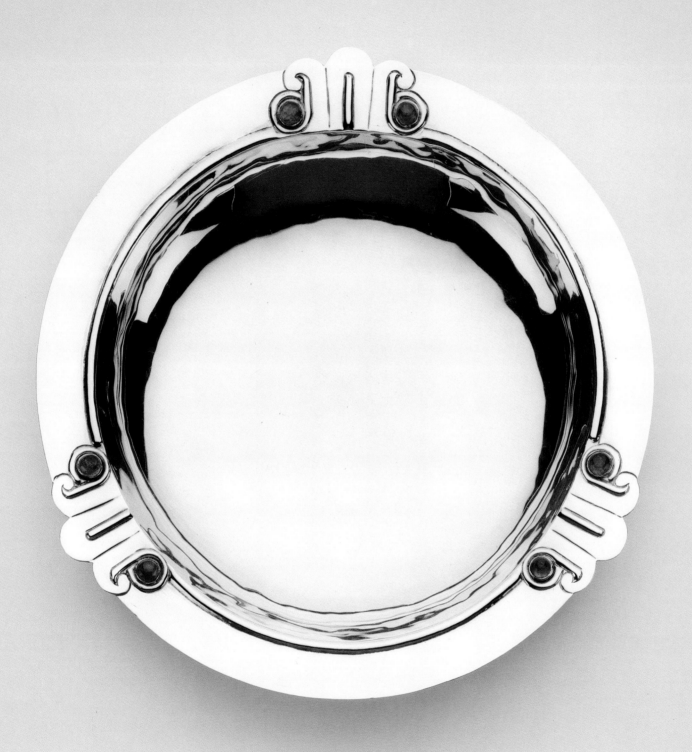

Necklace

Sterling

Chain: 16" (l) by ¹/₂" (w)
Pendant: 3³/₈" (l) by 1¹/₂" (w)

Collection of Anni and Edward Forcum

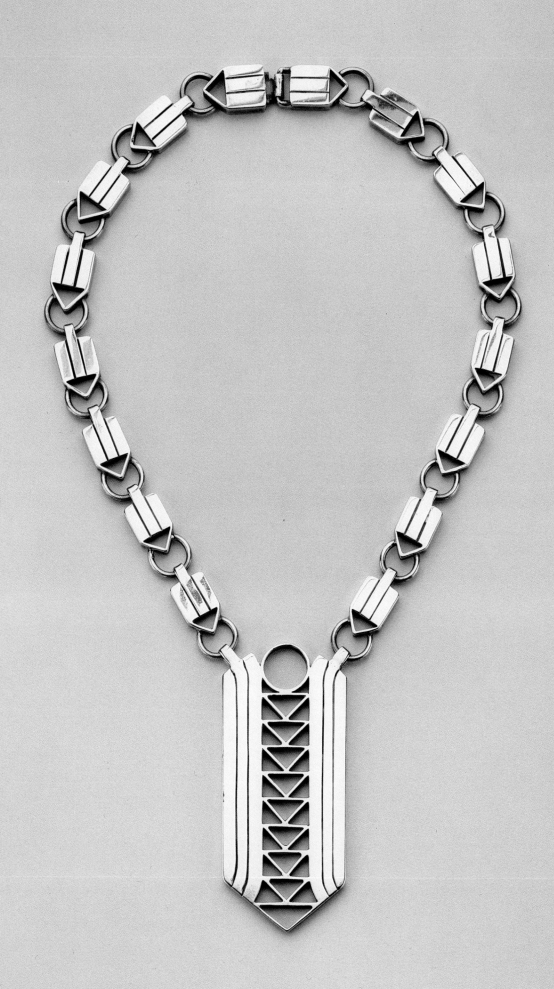

Brooch

Sterling

$3'' \, (l) \; by \; 2^{1}/_{2}'' \, (w)$

Collection of Hal Riney

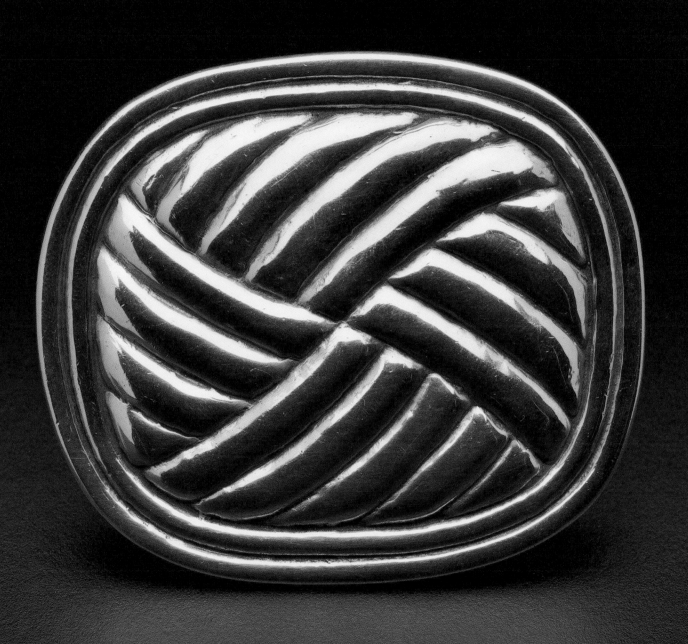

Pitcher
Sterling and Rosewood

$6^3/_4$" *(h) by* $6^3/_4$" *(l) (includes handle) by* 4" *(w)*

Collection of Cederwall Fine Art

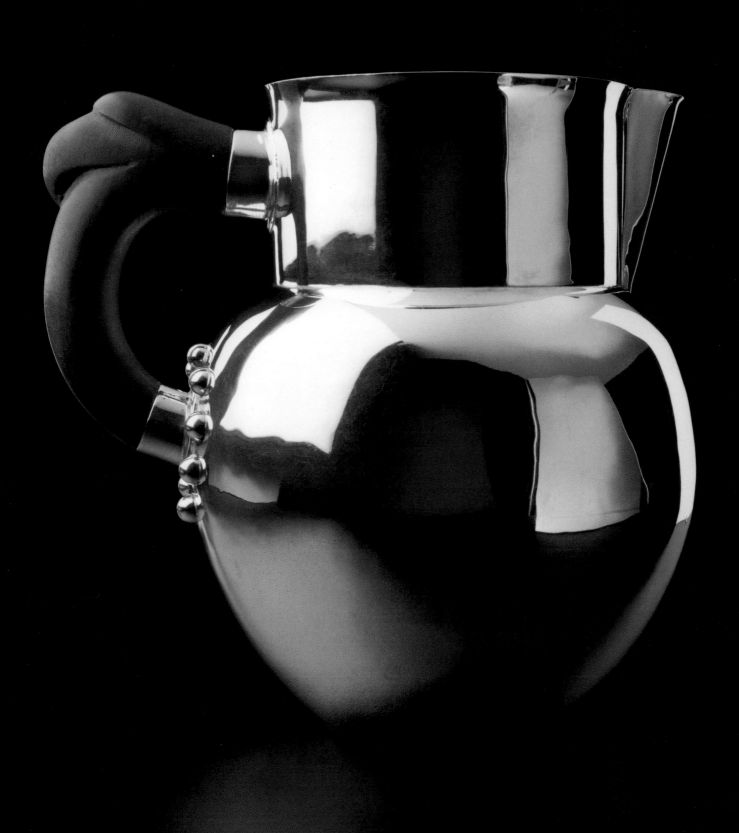

Box
980 Silver and Rosewood

$1^3/_4"$ (h) by $4^5/_8"$ (l) by $3^3/_8"$ (w)

Collection of Dan May

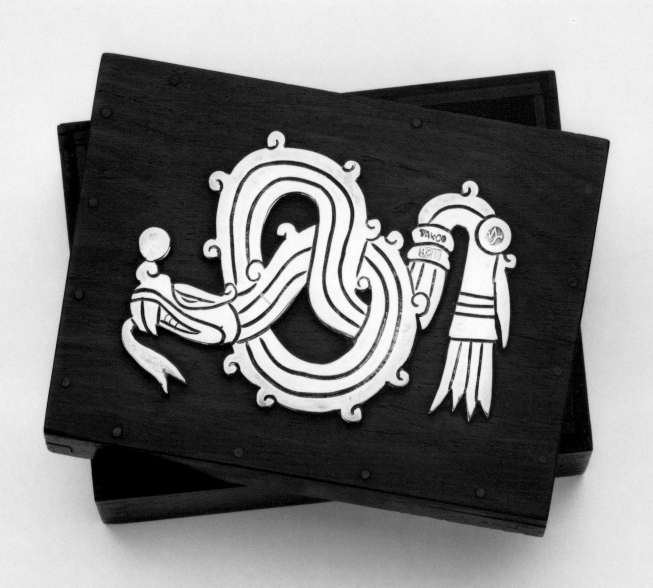

Knife

Sterling and Ivory

7" (l) by 1 1/2" (w)

Collection of Phyllis and David Goddard

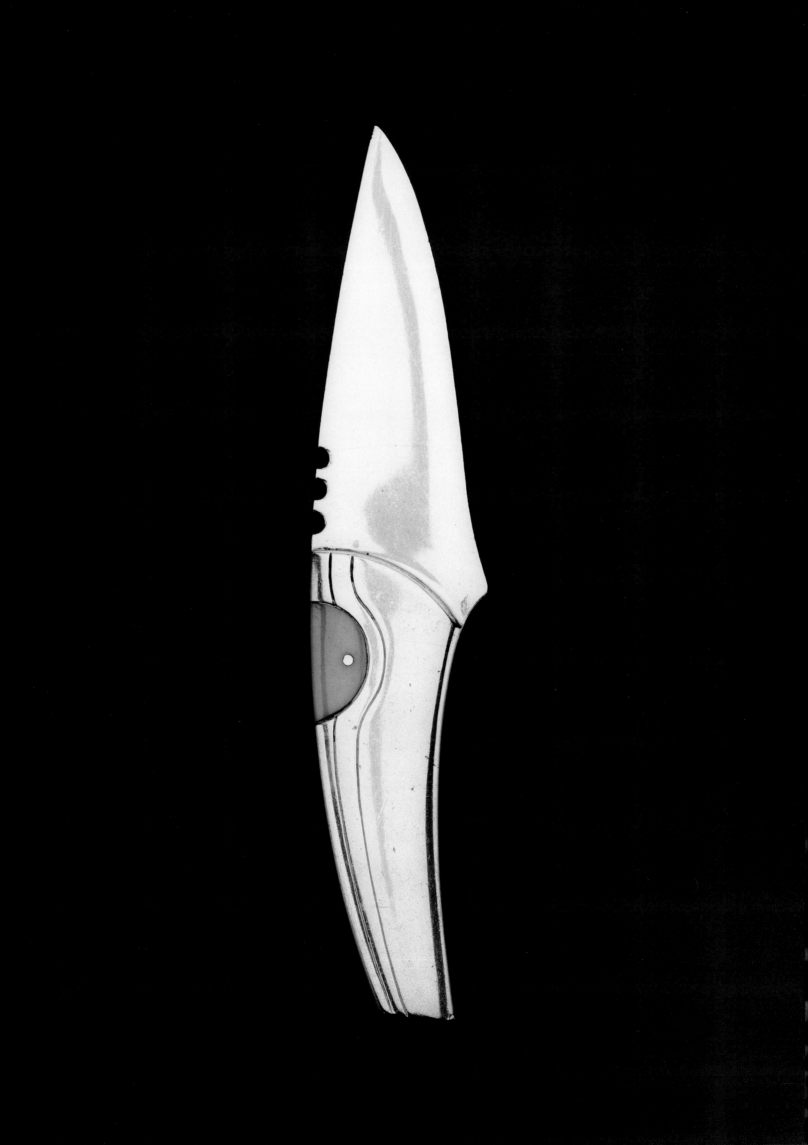

Bracelet
Sterling and Copper

$8 \frac{1}{4}" \; (l) \; by \; \frac{5}{8}" \; (w)$

Collection of Anni and Edward Forcum

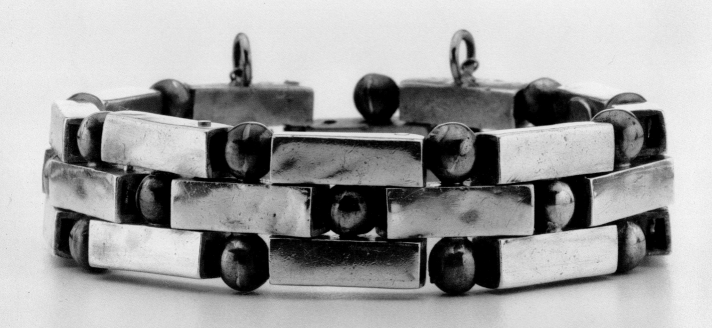

Brooch
Sterling and Onyx

$3^3/_8$" (l) *by* $1^3/_8$" (w)

Collection of Anni and Edward Forcum

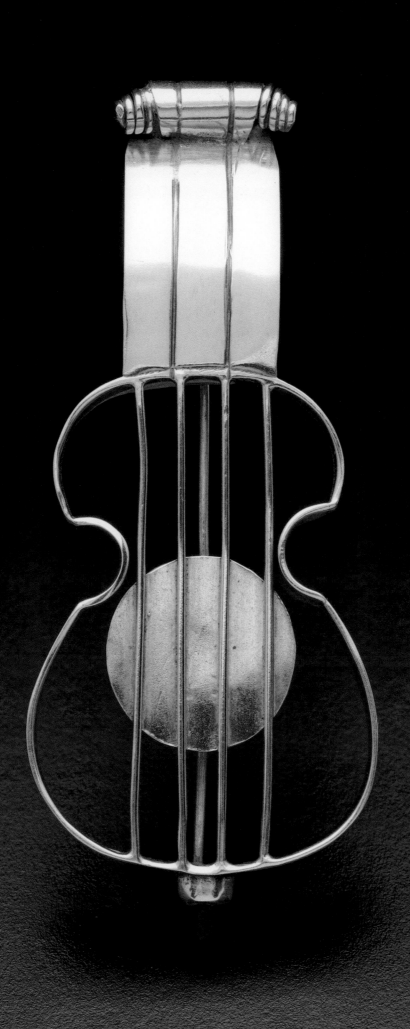

Brooch
Sterling and Brazilian Amethyst

$^3/_4$" *(h) by* 2" *(d)*

Collection of Anni and Edward Forcum

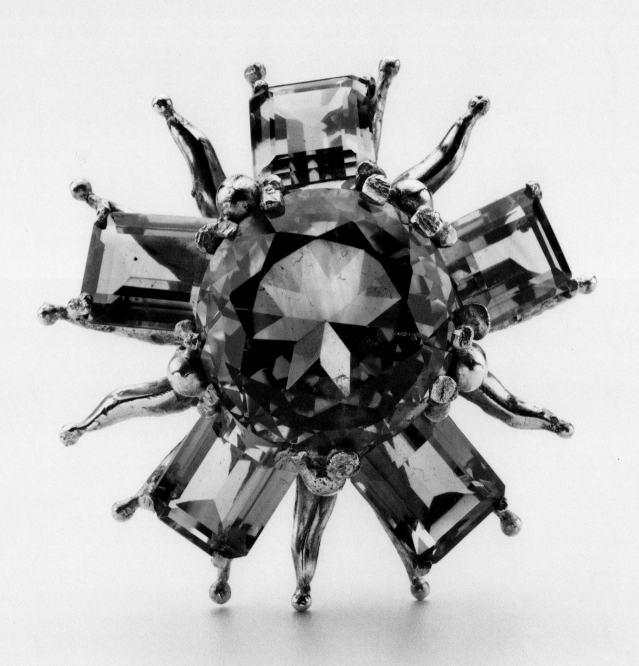

Box
Sterling and Amethyst

$1''$ *(h) by* $1^3/_8''$ *(l) by* $1^1/_4''$ *(w)*

Private Collection

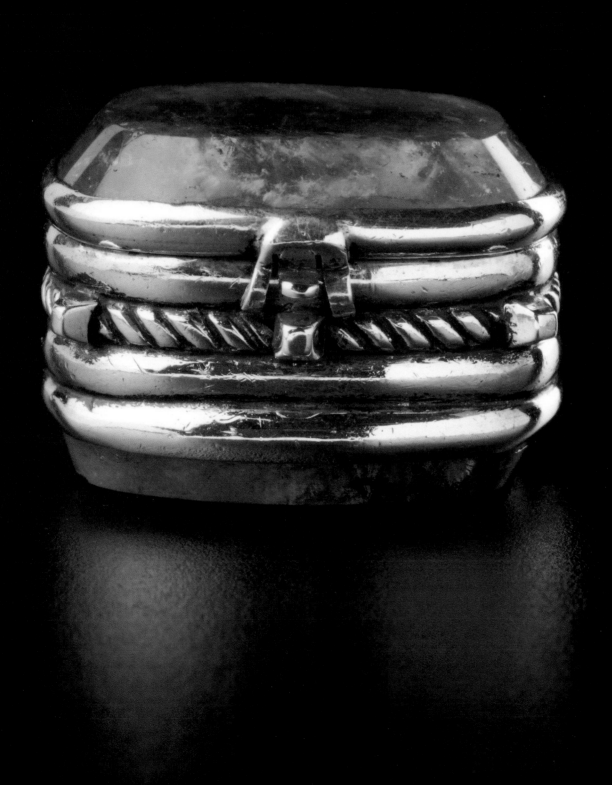

Belt Buckle
Sterling and Tortoiseshell

Mark covered by applied leather

$3^{1}/_{8}"$ *(l) by* $1^{3}/_{8}"$ *(w)*

Collection of Christopher Chew

Belt Buckle
Sterling and Tortoiseshell

$2^{1}/_{8}"$ *(l) by* $1^{1}/_{2}"$ *(w)*

Collection of Phyllis and David Goddard

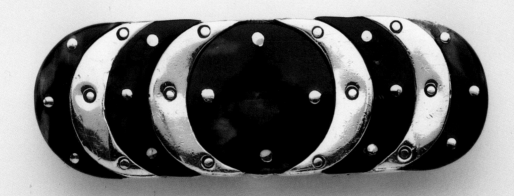
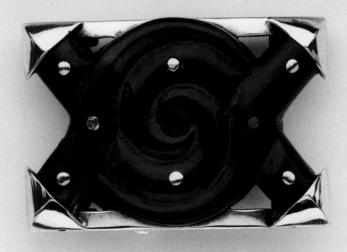

Spoon

Sterling

$4^{3}/_{8}"$ (l) *by* $1^{1}/_{2}"$ (w)

Private Collection

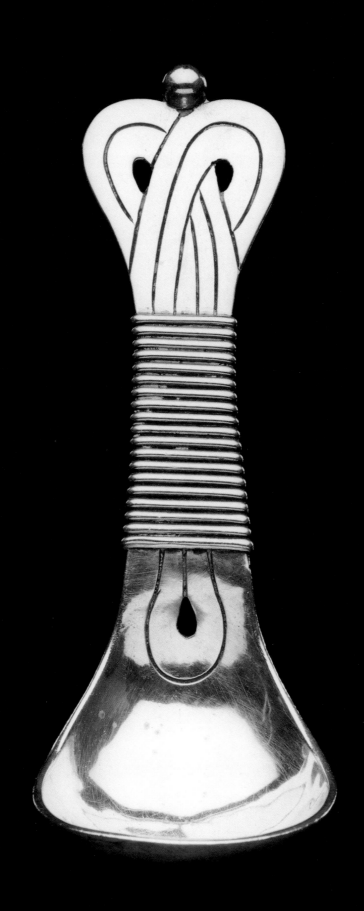

Bracelet
980 Silver

$2^5/_8"$ *(l) by* $2^1/_4"$ *(w)*

Private Collection

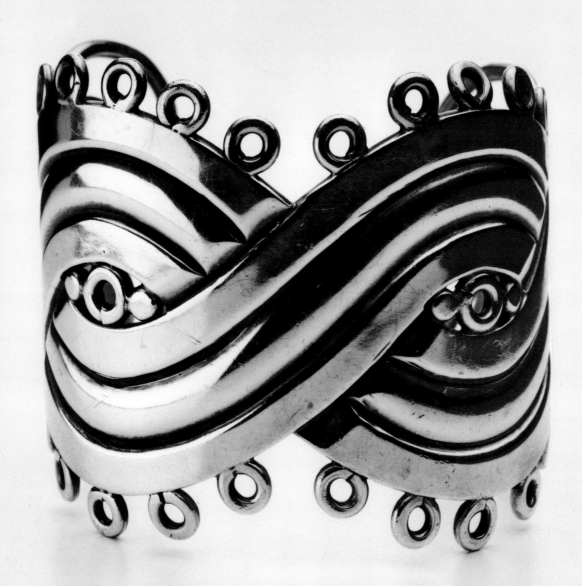

Salad Set
Sterling

Spoon: 9" (l) by 2¹/₈" (w)
Fork: 9¹/₄" (l) by 2" (w)

Collection of Sandraline Cederwall

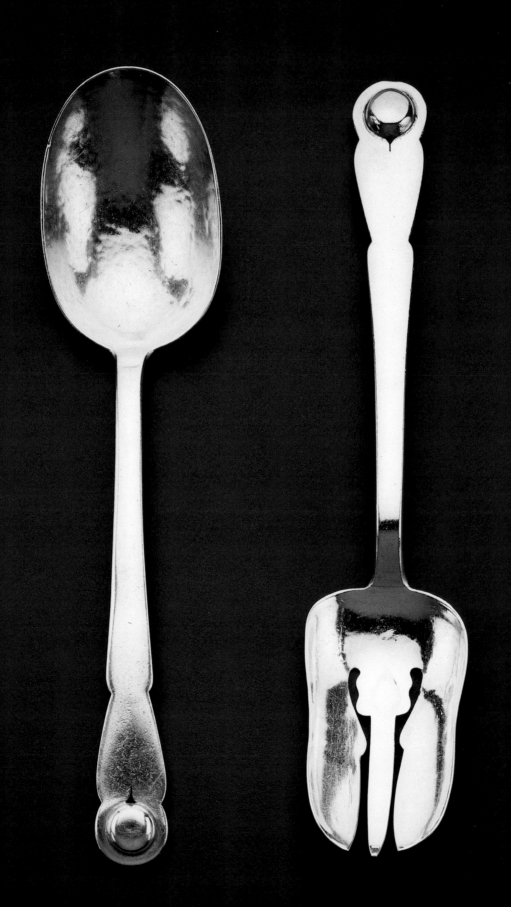

Sugar Bowl and Cream Pitcher with Tray

Sterling

Tray only signed piece
Sugar Bowl: 3¹/₄" (h) by 7" (l) by 2³/₈" (w)
Cream Pitcher: 3" (h) by 6" (l) by 2³/₈" (w)
Tray: 1/2" (h) by 9³/₄" (l) by 8³/₄" (w)

Collection of Anni and Edward Forcum

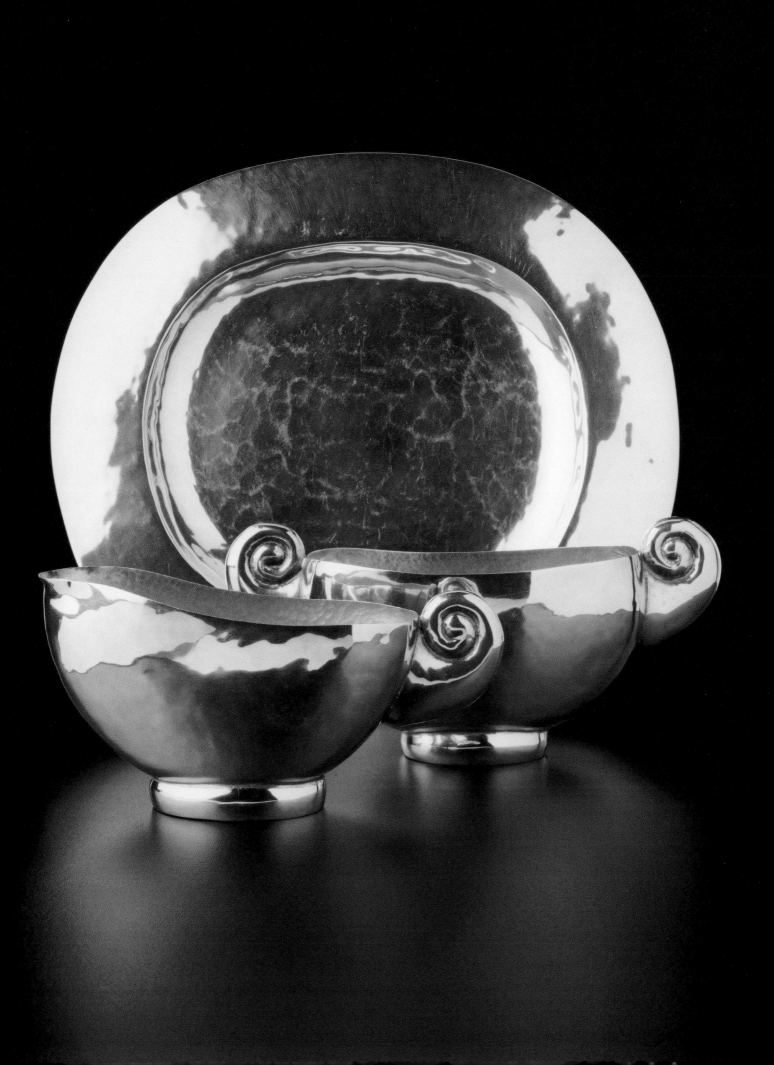

Box

Sterling and Tortoiseshell

$^{7}/_{8}"$ *(h) by* 5*" (l) by* 3*" (w)*

Collection of Phyllis and David Goddard

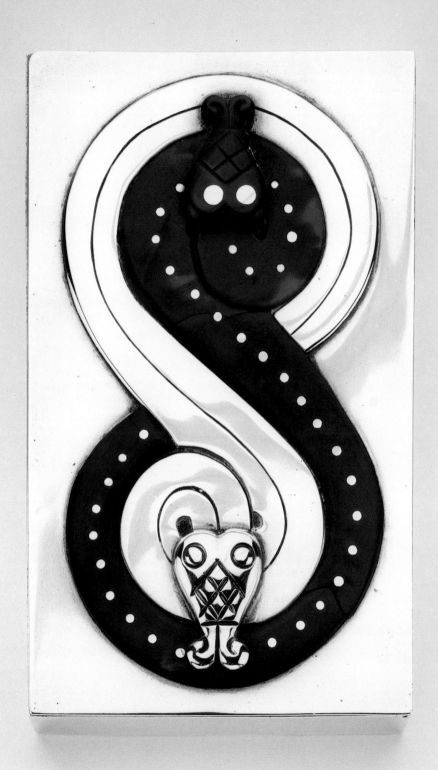

Container

Sterling

$2^{1}/_{2}"$ *(h) by* $2^{1}/_{2}"$ *(d)*

Collection of Dr. and Mrs. Armin Rembe

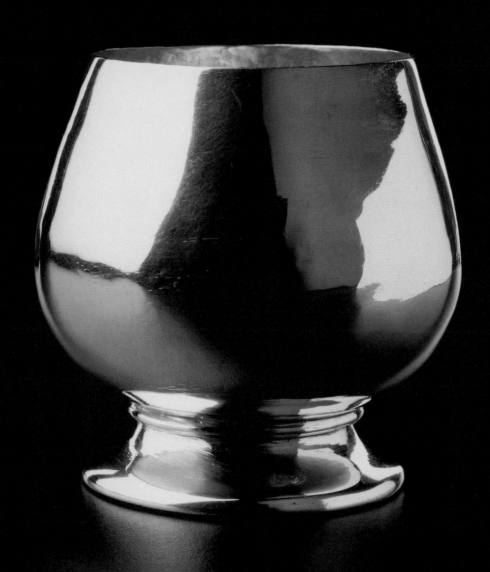

Belt Buckles
Sterling — bottom right
980 Silver — all others

Top Left: 1⁷/₈" (l) by 1³/₄" (w)
Top Right: 2¹/₈" (l) by 2" (w)

Bottom Left: 1³/₄" (l) by 1³/₄" (w)

Bottom Right: 2¹/₈" (l) by 1¹/₂" (w)

Collection of Christopher Chew

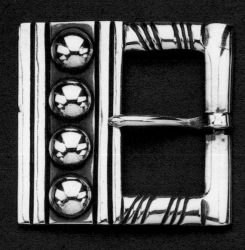
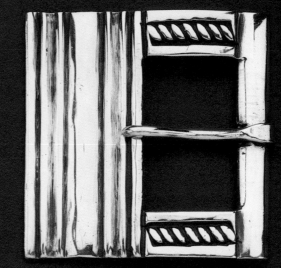
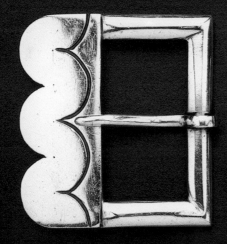
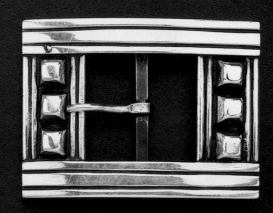

Necklace and Bracelet
Sterling

Necklace: 19¹/₂" (l) by 1¹/₈" (w)
Bracelet: 8" (l) by 1¹/₈" (w)

Collection of Sandraline Cederwall

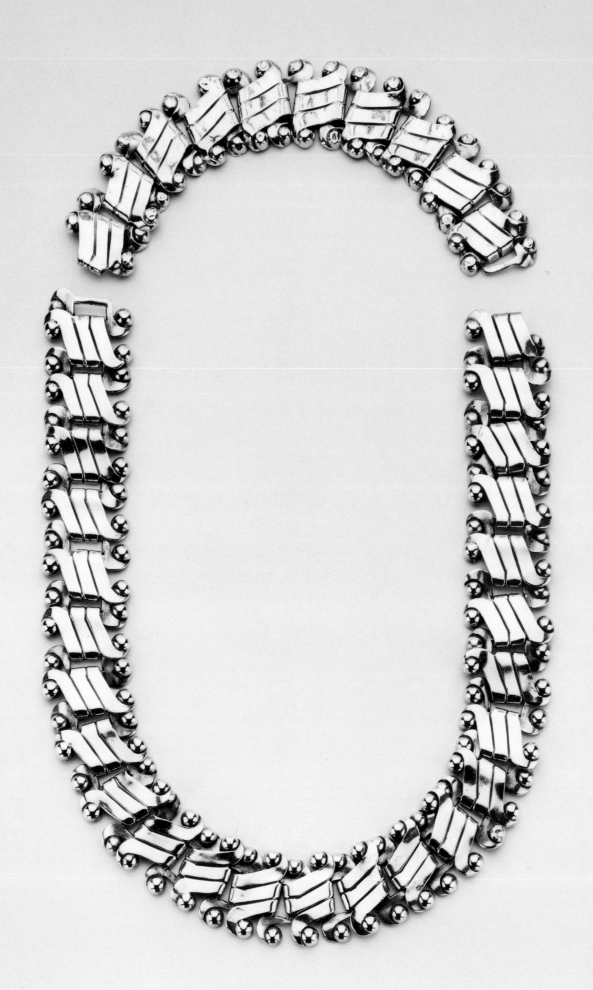

Salt and Pepper Shakers

Sterling and Ebony

2" (h) by 1³/₄" (d)

Private Collection

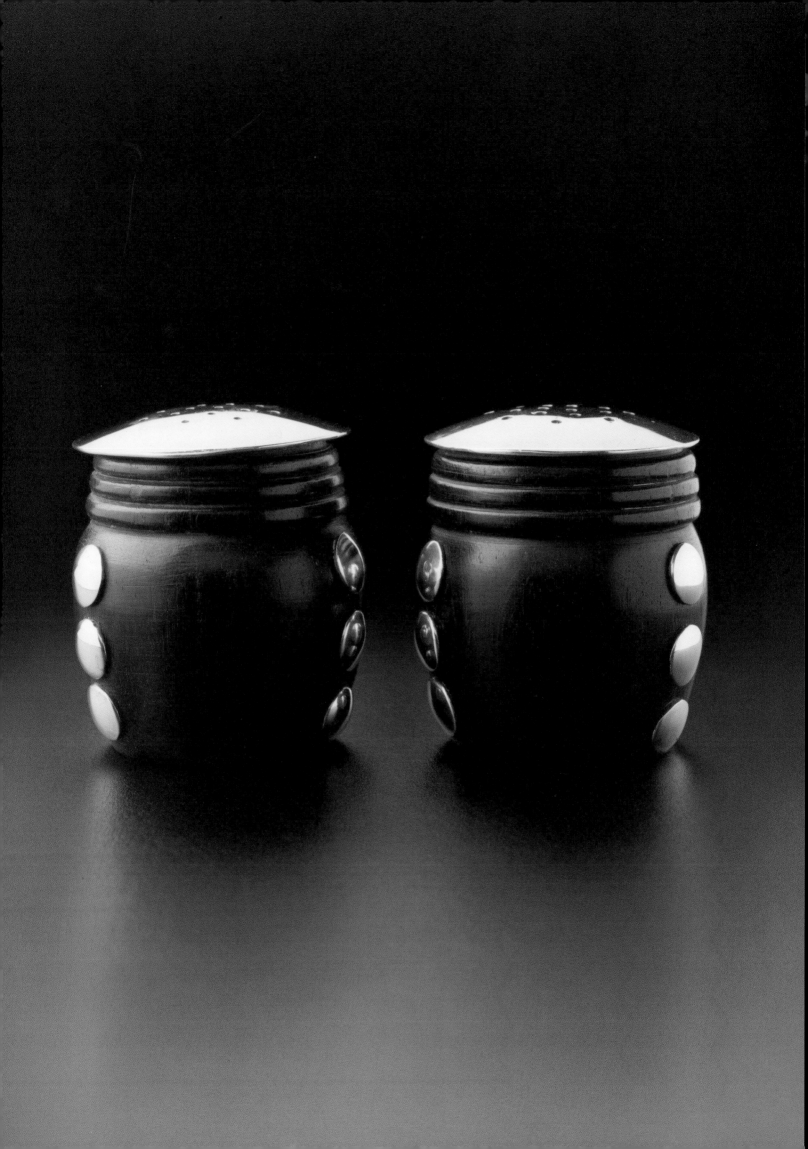

Brooch
Sterling and Copper

$4^{3}/_{8}''$ (l) by $2^{5}/_{8}''$ (w)

Collection of Hal Riney

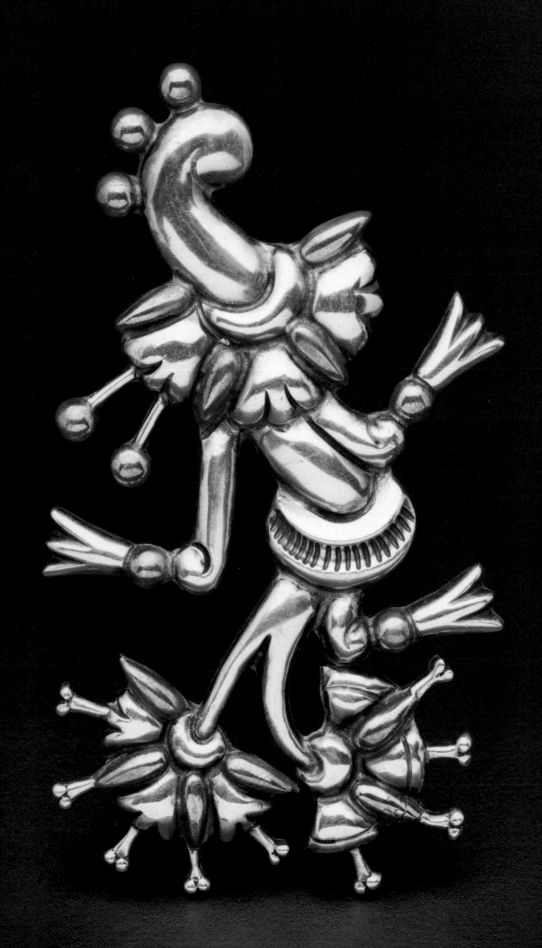

Bowl
Sterling

$3^1/4"\ (h)\ by\ 11^1/2"\ (d)$

Collection of Anni and Edward Forcum

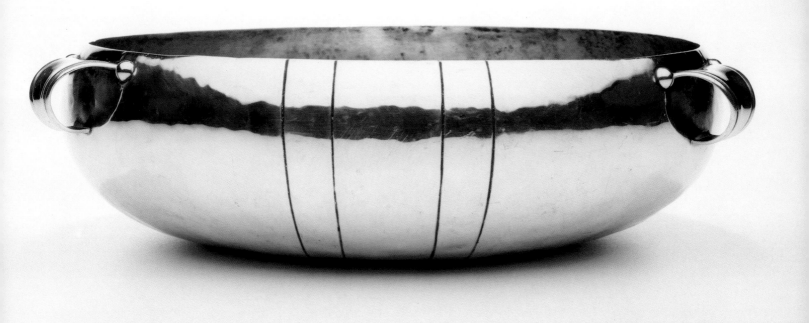

Candlestick
Sterling and Ebony

8$^{1}/_{2}$" (h) by 4$^{1}/_{2}$" (w)

Collection of Stella and Frederick Krieger

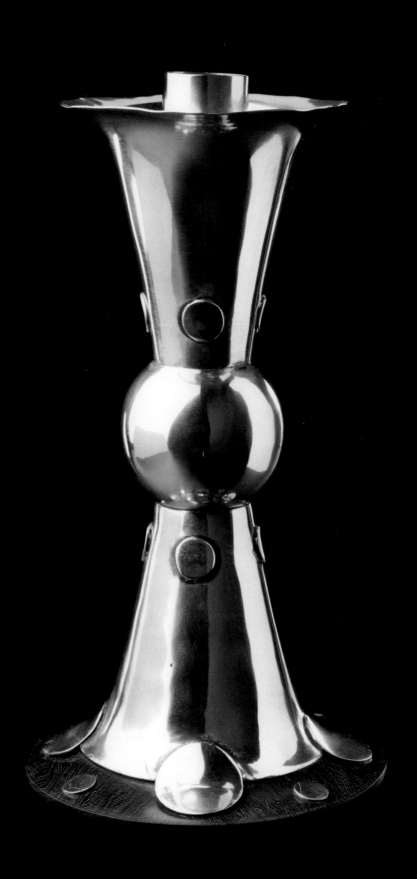

Sugar Spoons
Sterling

$3^{3}/_{4}$" (l) by $^{5}/_{8}$" (w)

Collection of Stella and Frederick Krieger

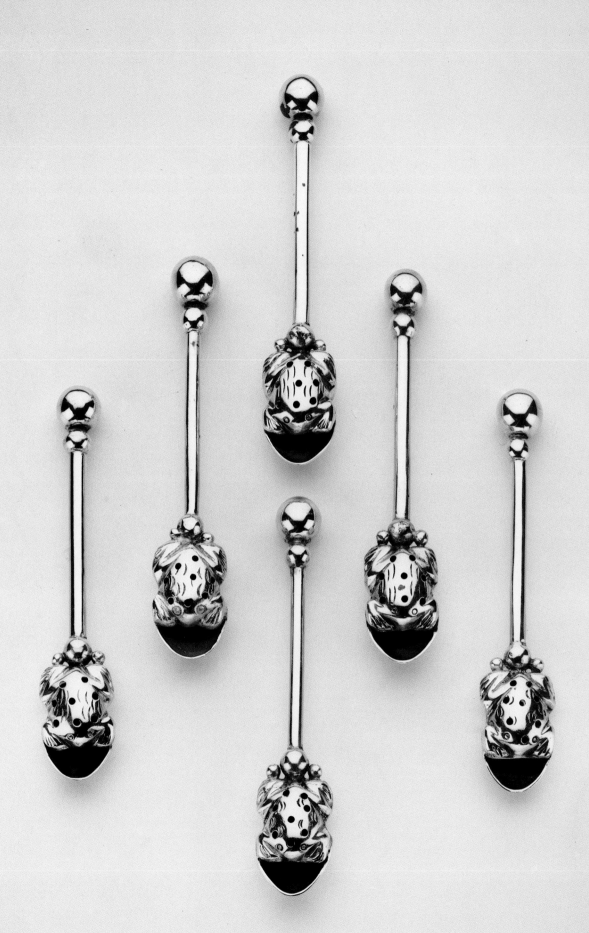

Bowl

Sterling

$2^{1}/_{4}''$ (h) by $6^{1}/_{4}''$ (l) by $5^{1}/_{8}''$ (w)

Collection of Dr. and Mrs. Armin Rembe

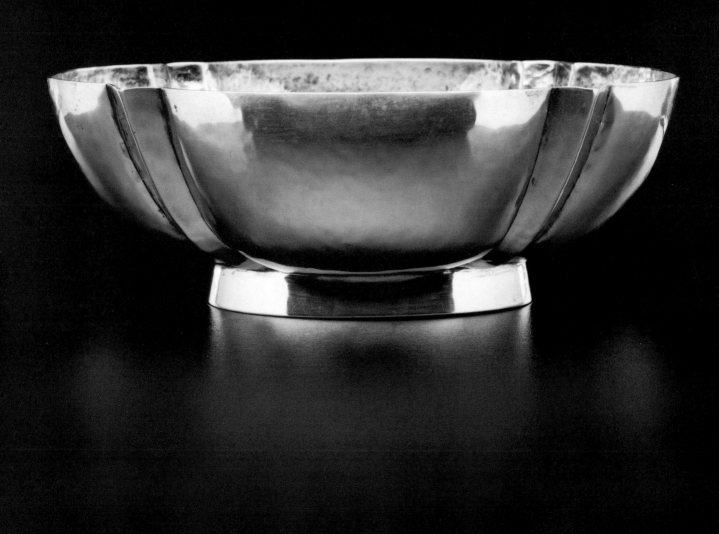

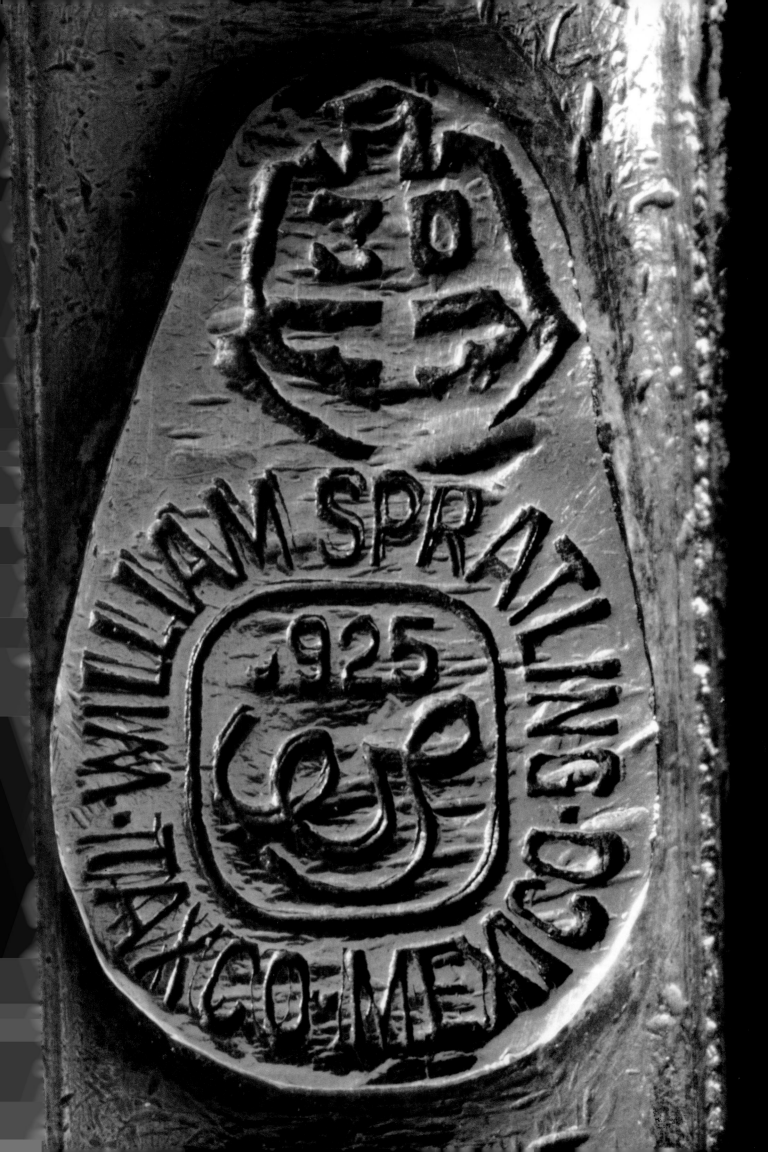

To identify silver jewelry, objects, hollowware, and flatware as original William Spratling designs and productions, one must look for his hallmarks. A piece designed and created in his workshop *(taller)* will bear a WS or a SPRATLING SILVER stamp. In general, the hallmark will be pressed into the silver. The WS has several variations according to the period during which the work was executed. The collector must further verify the authenticity of the hallmark itself. (See the hallmark chart on page 171.) From 1930 into the early 1940s, the simple WS or the oval SPRATLING SILVER stamp may be the only hallmark on a piece. More often, however, it will be accompanied by one or more of the other marks, such as 925, 980, TAXCO, STERLING, or TAXCO MEXICO. The 925 mark denotes that the item was created from a sterling silver standard; 980 declares that the silver used was purer in content than sterling, or a whopping 980 parts silver and only 20 parts copper. (Pure silver is 1000 parts silver; sterling is 925 parts silver and 75 parts copper.) Softer than sterling, 980 silver is more difficult for the smith to work but has a richer patina, tends to tarnish less, and is less likely to stain skin. In the early years, Spratling preferred the luster and other qualities of 980. I must caution here that a 980, 925, TAXCO, TAXCO MEXICO, or STERLING mark without a proper WS or oval SPRATLING SILVER does not verify original Spratling silver. His WS or SPRATLING SILVER mark is mandatory, with or without the complement of the other stamps. It is thought that in the 1930s the SPRATLING SILVER oval stamp not only identified the work as

from Taller Spratling but also guaranteed that the item was constructed from 980 silver. By 1944, according to Penny Morrill in *Mexican Silver*, due to difficulties with production control, the 980 hallmark was dropped completely. By 1945, apparently, the oval SPRATLING SILVER no longer guaranteed 980 silver content either—only that the work was of the highest quality and designed by William Spratling. The simple WS hallmark was used by Spratling workers in the earlier 1930s. That brandlike mark evolved sometime in the later 1930s into a symbol that provided more information. The expanded stamp for WS was SPRATLING MADE IN MEXICO; the words surrounded the WS. Perhaps by designing a more complex hallmark, Spratling also hoped to deter moonlighters and plagiarists. For about five years beginning in 1940 Spratling was involved in a concurrent business venture with Victor Silson to manufacture a line of costume jewelry made of a silverlike metal. Some Silson/Spratling designs were marked Patented and produced in a factory in the eastern United States. Others bear a Patent Pending mark. The round Silson/Spratling medallion read "Spratling of Mexico, Silson Inc." and was generally applied to the jewelry, not pressed into it. In the late 1940s Spratling replaced the brandlike WS with a swirling scripted WS. He continued to use his new scripted hallmark until his death. At first it was used in its simplest form. Then in the mid to late 1950s he encircled the plain WS with more information: WILLIAM SPRATLING TAXCO MEXICO and 925. About 1949 Spratling entered into yet another ill-fated business with a silver company in Mexico City. While continuing to produce silver designs from his own workshop in Taxco, he agreed to design pieces for Conquistador, S.A. These pieces

were marked with a circular stamp reading SPRATLING DE MEXICO with the word STERLING stretched horizontally across the trademark. Other stamps that are found on Conquistador/Spratling products include the Eagle 13. About the time the scripted WS appeared (1948–49), the Mexican government decreed that all silver for export bear a national hallmark. They designed a stamp that outlined the full front-on body of an eagle with its wings puffed at its sides and its head turned in profile. This hallmark guaranteed that the item was produced from a silver content of at least 925 (sterling). In the center of the bird was a number. The numbers 1 and 3 indicated generic or smaller workshops in Mexico City or Taxco. The larger Tallers had their own identifying number(s). Two of Spratling's eagle stamps were Eagle 30 and Eagle 63, used until his death in 1967. Around 1970, the Mexican government retired the eagle hallmark and assigned each silver shop a series of letters and numbers. Since Alberto Ulrich purchased the Spratling estate from the Mexican government after Spratling's death, each of his reproductions and reissues of Spratling's work bears the TS-24 as well as a slight variation of the elaborated scripted WS. At times a third mark, DT, will be found along with the TS-24 and the WS. DT stands for Don Tomás Vega García, now the head silversmith in Ulrich's Taller Spratling. The DT hallmark recognizes that the silver item was made by Don Tomás. It is an honor afforded Don Tomás since he is the oldest smith in the Spratling taller who worked as a boy with the master himself. During his long tenure in Taxco, Spratling at times also designed and produced furniture, textiles, gold jewelry, tin and copper hollowware and objects. Each item was identified with the name William Spratling. In the case of

furniture, the leather or wood was actually branded. The hallmark for his gold jewelry was 18K WS. Tin or copper objects displayed marks similar to the symbols found on his silver pieces. Unfortunately, an exact chronology is impossible to provide. Records that date the inauguration and termination of trademarks and hallmarks are either nonexistent or unclear; although marks were documented on paper, there is no guarantee that stamp usage was coordinated accordingly in the workshop. The use of old and new hallmarks sometimes overlapped. The best advice I can give the collector and connoisseur is to examine authentic hallmarks carefully and to study all the Spratling silver jewelry and objects you can get your hands on. After years of experience, you, as I do, may be able to judge a piece as original by William Spratling by a sense of quality, feeling, and invention. But beware: If a piece does not have the authentic hallmark(s), it may only be attributed to Spratling.

—*Sandraline Cederwall*

Hallmark Chart *

Compiled by S. Cederwall, E. Forcum, and P. Goddard

1 9 3 1 — 1 9 4 5

1 9 4 0 — 1 9 4 5

Items with this mark not made of silver.

1 9 4 7 — 1 9 6 7

S i n c e 1 9 7 9

Marks Used on Tin, Copper, Furniture, and Wooden Objects

Marks Used on Gold

*Dates are approximate

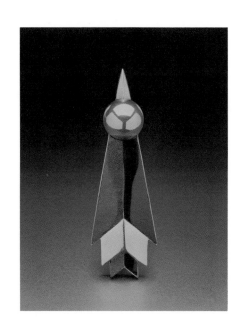

Epilogue

Inspired by his surroundings,
William Spratling's designs were absolutely unique.
As a result, there is a continual and rising interest in his work.
He was a prolific artist, and as we put together this book,
we discovered examples of his jewelry,
flatware, and hollowware that we had never seen before.
It was not possible to show it all.
Though Spratling was a man of manifold interests and talents,
this publication focuses on his silver.

Our purpose is to give the reader a sense of his design and style.
We hope that, in addition to revealing the beauty of William Spratling's work,
this book will be a useable reference for collectors
familiar with Spratling and for those who become interested
after seeing his pieces for the first time here.

Acknowledgments

It has been a great compliment to have the opportunity to update, revise, and expand our *Spratling Silver* book originally published in 1990. I thank Nion McEvoy and Jack Jensen of Chronicle Books for recognizing the time was right to put it back into print in a larger edition.

I was delighted to find Woody Lowe eager to join me once again to work on the book he so elegantly designed the first time around while working as art director and designer in San Francisco at Hal Riney and Partners advertising agency. With tremendous pride and energy, Woody has made this 2000 edition of *Spratling Silver* superb.

All of the extraordinarily handsome photographs that comprise the plate section of this beautiful book were executed by Avis Mandel or Alan Ross. It was pure pleasure to work with such accomplished and talented photographers.

Alan Freeland, my lawyer and good friend, again enthusiastically supported our efforts by assisting with important legal matters of the publishing world. I am deeply indebted to him.

My dear friend Mary Anita Loos, always a great inspiration, gave freely of her files and memoirs. Now eighty-nine years old, she has spent many hours describing to me her experiences and adventures with her friend William Spratling. Her stories have given me a warm and intimate insight into his character and energy.

This centennial edition expanded the hallmark information originally compiled by Edward Forcum and Phyllis Goddard. With their contribution *Spratling Silver*, always appreciated as a work of art in itself, is also valued as an important reference journal.

I am grateful for the essay Barnaby Conrad wrote in 1990. It has stood the test of time and is reprinted here in its entirety.

I'll always treasure the experience of spending a week at Alberto Ulrich's Spratling Ranch in Taxco Viejo ten years ago while searching for old photographs and drawings for the book. Alberto was a gracious host and very helpful with my research.

Others who have lent their support and enthusiasm for this second edition include David Goddard, Ron Belkin, Cindy and Stuart Hodosh, Carol Boss, Ande and Peter Rooney, Kate Kelly, Jean Hakes, Bob Brown, Diane Patrice Garcia, Susan Dupuis, Christina Wilson, and Sara Schneider. I would like to extend special thanks to John H. Garzoli.

My family and friends who were involved in our first edition have not been forgotten. I'd also like to mention Anni Forcum, Stanley Marcus, and all of the people who lent their prized pieces of Spratling silver to be photographed. I deeply appreciate the confidence and support that my idea and concept for this book have received from the beginning from Hal Riney.

My role in the making of this book required involvement in every aspect from historical research and silver selections to writing, art directing, and coordinating a team of talented artists and designers. For me, the production of *Spratling Silver* was a labor of love well worth doing.

— *Sandraline Cederwall*

Bibliography

Books and Articles

"American Founded Mexican Silver Design." *Mexico City News*, 18 December 1987.*

Castrejón, Dr. Ruby N., and Dr. Jaime D. Castrejón, *William Spratling*, Mexico.*

Centro Cultural/Arte Contemporáneo, A.C. *William Spratling*. Mexico: Imprenta Madero, S.A. Tipografía Formación, 1987.*

Davis, Mary L., and Greta Pack. *Mexican Jewelry*. Austin, Texas: University of Texas Press, 1963.

Figueroa, Leslie C. de, *Taxco the Enchanted Hill Town. A Handbook for Tourists*, 1960.

García-Noriega Nieto, Lucía. "Mexican Silver: William Spratling and the Taxco Style." Translated by Ahmed Simeón. *The Journal of Decorative and Propaganda Arts*. 10 (Fall 1988): 42–53.

"A Genius of Mexican Jewelry." *New York Times*, 2 June 1985.*

Greenhaw, Wayne. "Auburn Man, Mexican Hero." *Alabama Magazine* (December 1985): 16–17.

"In Mexico, Spratling Means Silver." *New York Times*, 17 December 1987, sec. C1.

Lesserwolf, Toni. "Silver Bill, William Spratling, Creator of Modern Taxco Silver." *Metalsmith*, sec.10 (Winter 1990): 30–35.

Marion Koogler McNay Art Institute. *The World of William Spratling*. San Antonio, Texas: The Press of Ozzie Baum, 1965.

Morrill, Penny Chittim, and Carol A. Berk. *Mexican Silver, 20th Century Handwrought Jewelry and Metalwork*. Atglen, Pa.: Schiffer Publishing Ltd., 1994.

Museo Nacional de Artes e Industrias Populares. *Mexican Silverwork*. Mexico, 1952.

Spratling, William. *File on Spratling: An Autobiography*. Boston: Little, Brown and Company, 1967.

————. *Little Mexico*. Foreword by Diego Rivera. New York: Jonathan Cape and Harrison Smith, 1932.

Sucesores de William Spratling S.A. *Silver by Spratling*. Taxco, Mexico: Sucesores de William Spratling, S.A., 1987.

————. *Spratling Silver in Taxco*. Taxco, Mexico: Sucesores de William Spratling, S.A., 1988.

Taxco, Ciudad Maravillosa. Helio, Mexico.

"Ted Wick in Taxco—Homage to Spratling." *Mexico City News*, 22 February 1987.*

Complete information unavailable.

<u>Films</u>

The Man from New Orleans, Warner Bros. Pictures, Inc. Produced by Gordon Hollingshead.
Photographed and directed by Luis Osorno Barona.

<u>Books by William Spratling</u>

Old Plantation Houses in Louisiana

The Art of Pencil Drawing

Sherwood Anderson and Other Famous Creoles

A Small Mexican World

Little Mexico

More Human Than Divine

Escultura Precolumbiana De Guerrero

File On Spratling: An Autobiography

Page 172: Brooch: Sterling, Onyx, and Obsidian; 4³/₈" (l) by 1¹/₂" (w);
Collection of Anni and Edward Forcum